LOWELL
IRISH

DAVID D. McKEAN

Published by The History Press
Charleston, SC
www.historypress.net

Opposite: Walter at his first communion, St. Patrick Church, 1955. *Hickey collection.*

First published 2016

Manufactured in the United States

ISBN 978.1.46711.784.5

Library of Congress Control Number: 2015956820

To my friend and mentor Walter V. Hickey

I first met Walter when I was working on a project as a park ranger for Lowell National Historical Park. At that time, Walter worked in the Special Collections room at the Pollard Memorial Library in Lowell. Needless to say, I was researching the early Irish history of Lowell. The room was filled with researchers and amateur genealogists. In their midst was a Moses-like figure to whom all were drawn. People yelled out a name, and Walter would respond with a date and a primary source. Someone would ask when an event happened, and he would deftly, without looking, reach into a file and pull out a roll of microfilm reels and blindly load it onto a machine. It was like watching Michelangelo at work. He was the master at his craft. Over that summer, I relied on Walter's resources several times. The man was and is a walking encyclopedia of Lowell history.

We soon learned we had similar interests. We both went to St. Patrick School. We were both from the Acre. We both sought our Irish ancestors. We both had an odd fascination with the slate stones of St. Patrick Cemetery and knew they could tell the story of the Irish better than anyone. I would always try to one up him by finding an article he had never seen before, but I never won. He knew it all.

Our first quest was to find Hugh Cummiskey's grave. We used every resource we had for naught. Being the true detective he is, Walter finally found the key, and Hugh was given the marker he deserved. That was only the beginning. Since then, we have collaborated on several projects. We have taken road trips to Charlestown, Cambridge and the Massachusetts State Archives to find the story of Lowell's Irish pioneers. To be honest, I'm not sure where his or my research begins or ends. They have amalgamated over time into collaboration. Much of what you read here might have been started by Walter.

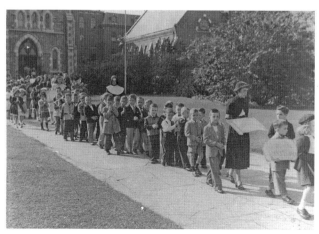

Together I hope we have honored those who have come before us and have added to the research done by others who have attempted to tell the story of those who left their homes across the sea, came to a foreign land where they were often not accepted for who they were or their faith, worked at the most menial and often dangerous jobs and yet became integral to the life and culture of the city. Their story deserves to be told and remembered. It is our hope we have done our part.

CONTENTS

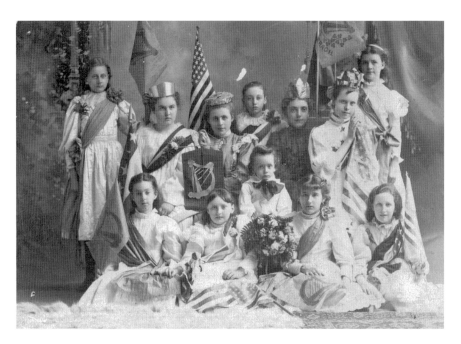

Students from St. Michael's School celebrating St. Patrick's Day, date unknown. *Archives of St. Michael Parish, Lowell, Massachusetts.*

PREFACE

I believe I was born at the right place at the right time. I grew up on the corner of Broadway and Walker Streets in the Acre neighborhood. There were still chestnut trees on Waugh Street, where we would have wars by pelting one another with the thorny missiles. Walker Street was still cobblestoned, and the sound of car tires rumbling along would lull me to sleep. The block of tenements I grew up in was a community unto itself. Every neighbor knew one another's business, maybe too much. Almost every kid in the neighborhood attended St. Patrick School, and almost every kid went to the 8:30 a.m. Mass, when the nuns would take attendance. The church was our home, our extended family.

It was not uncommon to hear older neighbors and parishioners with Irish brogues. Walking through the neighborhood, you can see that many stores, markets and barrooms still retain the names that reflect their Irish proprietors. For the eight years that I attended St. Pat's, I would walk by a storefront that displayed a picture of St. Patrick's Holy Name Society of 1928. Irish songs (mostly Irish American, to be honest) were taught to us in school and Irish hymns in church. Step dancing in the school's basement was a Saturday regular for many girls and boys. Though my mother's family was proudly French Canadian, most of my cousins had Irish surnames (Donahue, McArdle, Sullivan and McLeod). We were that mixed generation where two cultures merged. For me, both were respected and promoted.

Probably the greatest gift I received by growing up in this period was hearing the stories of family members and neighbors. My father was the first, filling my head with images of kids swimming in the canals and lighting

gas lamps along Broadway. This was fostered by some older residents who told stories of families leaving Ireland and the prejudice they met when they settled here. It was the church and the neighborhood where they found support and succor. As I grew older, I began collecting these stories, sometimes finding their truth had ballooned with each retelling.

My first teaching assignment was at St. Patrick School, and I was privileged to be able to pass on my love of history and especially the story of Lowell and Lowell's Irish pioneers. I found that when I worked as a park ranger at Lowell National Park, people would be captivated if I told history as a story rather than as a singular event.

Slowly, I began writing these stories down and collecting memorabilia. I regretted seeing black velvet vestments with skull and crossbones and large Gregorian chant books being thrown in trash bins and the original baptismal font being ground into rubble. Folks began hearing of our collection, and today, we have a wonderful archive of photos, prints and artifacts that tell the story of the Irish in Lowell. But how much has been lost?

Probably the greatest recent event in recording the story of the Irish in Lowell has been the archaeological dig conducted by Dr. Colm Donnelly from Queen's University and UMass–Lowell. I was privileged to be a small part of the dig in Lowell and to walk the actual path that Hugh Cummiskey took when he left his home in Crossan, County Tyrone. It was an experience I will never forget.

I have not done this alone. Over the years, I was mentored by other storytellers like Jack Flood, Arthur Cryan, Elizabeth (the priest's housekeeper, whose accent you could cut with a knife), Dick Corcoran, Paul and Freddy Sheehy and my in-laws, Dorothy and Charlie McKenzie. Several priests of Saint Patrick's had the vision to recognize that our story had to be preserved: Father Dick Conway, Father Tom Powers and Father Dan Crahan. There have been volunteers who have spent hours on their knees in the cemetery uncovering stones and inscribing names and dates to record that first generation of Irish. Then there are the untold numbers who have sent e-mails and notes, each telling a little vignette of an Irish ancestor or event but still adding to our collective story.

I chose to take on this task because I believe that my generation is one of transition. We were part of that hyphenated generation (Irish American, Greek American, Canadian American, et cetera). We were caught between two worlds. We were fully American but were always reminded that we had another home.

But our work is not done. We merely have done our small part. It is up to the next generation to continue the story and add the next chapter.

ACKNOWLEDGEMENTS

It is nearly impossible to thank each and every person who has helped this book come to completion. First of all, thanks go to the dozens of people who sent in photos. Unfortunately, we were very limited in the number of pictures we could use. But your efforts were not in vain. As the 200th anniversary of Cummiskey's arrival in Lowell approaches, we are archiving all of the pictures for future generations to be able to know the story of the past and today.

When I received an e-mail from The History Press to begin this project, I wasn't sure of its outcome. Tabitha Dulla, Karmen Cook and Julia Turner, my editors, have been ever so patient answering even the most inane question.

My friends at the Lowell Irish Cultural Committee at St. Patrick Parish have always been there providing support and resources for the many projects I've initiated.

There have been a number of people who have helped with the narrative part of the project. I'm fortunate to have worked with fellow historians who have shared their work over the years, namely Walter and Karen Hickey, Richard Howe, Eileen Loucraft and the late Ed Harley. We have all built on one another's work to tell the story of Lowell's Irish community. Traci St. Peter, Brenda McKean and Caitlin McKean have read the text over and over and helped me with those grammatical errors the Sisters of Notre Dame never were able to teach me. Once again, Walter Hickey came to my defense and stepped up to be my history reader. Even though I read the text a dozen times, there were errors in dates and names that he caught before it went to print.

ACKNOWLEDGEMENTS

I have met some wonderful people along the way who share my passion to record our part of Lowell's history. I hope I do not leave anyone out: Barbara Bond, who maintains the Archives of St. Michael Parish; Eileen Berube from Lowell General Hospital (Saints' Campus); Sister Mary Charlotte Barton and Sister Mary Salvadore of the Archives of the Grey Nuns of the Sacred Heart; Jim O'Donnell from the O'Donnell Funeral Home; Jack McDonough from the McDonough Funeral Home; and personal family collections from Walter and Karen Hickey, Guy Lefebvre, Molly Sheehy, Tom Malone, Garrett Sheehan, Paul Corcoran, Rosemary Noon, Susan Donahue McCarthy, Ryan W. Owen from *Forgotten New England*, Jane McArdle, Donna Reidy and Jim Latham. Also many thanks to the librarians from the Archives of St. Patrick Parish, the Library of Congress, the Archives of the Sisters of Notre Dame de Namur (Ipswich Province and Cincinnati Province), the Archives of the Commonwealth of Massachusetts and the Archives of the Sisters of St. Mary of Namur.

INTRODUCTION

The grand experiment of manufacturing cotton textiles first occurred on the Charles River in Waltham, Massachusetts. This successful feat inspired the Boston Associates, the financial backers for innovative enterprise, to look for a newer and grander venue to expand their hopes of bringing the industrial revolution to America. The year was 1822; Kirk Boott was appointed agent manager for the new project. Wherever this new industrial city was to be built, it needed to be located at a place that could provide the water power necessary to power the cotton looms that would bring wealth to the financial backers and turn America from an agrarian into an industrial nation.

The dam at the head of Pawtucket Falls, September 11, 1875. Lowell Canal System, Merrimack River, above Pawtucket Falls, Lowell, Massachusetts. *Library of Congress.*

INTRODUCTION

The ideal location would be along the banks of the Merrimack River in Chelmsford, Massachusetts. The plan was that the river would provide the power, and the Yankee mill girls from the New England farms would provide a ready supply of labor. The Pawtucket canal, a transportation canal already in the area, could potentially be converted into the power canals that would bring water from the river to power the mills.

The stage was set. Now all that was needed was the erection of the mills and the transformation of the canals. A new source of workers was needed that was readily available. Local Yankees and others would be drawn to this new venture to take on the heavy labor and work cheaply to ensure the investors would get their return. And so enter the Irish.

ROOTS

A labor force that was willing to work hard and work fast was needed to build the town that would eventually be named Lowell. Yankee work crews could provide the labor but not in the numbers required. The Irish would be called on to fill in the gaps. Tensions would evolve between the two groups. As the success of the first mills became apparent, more labor was needed, and with that came greater numbers of the working Irish. Though it was not explicitly stated, the goal was to have the Irish do their jobs for a short while and return to their homes and workplaces in Boston. Lowell was being built as a model of American enterprise and a local version of the industrial revolution that had taken place in England. What was not expected by the Yankees was that the Irish were here to stay.

WHEN THE IRISH CAME TO TOWN

Kirk Boott, that first manager of the new industrial town, was a Boston native. His family had a long history in the town and was involved in a number of successful enterprises. The city of Boston was a hive of businesses and new building projects, one of which was the leveling of Boston's hills and filling in areas to make new building space. One of these work crews was led by a man who would become one of the leading Irishmen in Lowell's story: Hugh Cummiskey.

It is probable that the two met or were introduced because of their mutual needs. Boott needed a ready supply of laborers, and Cummiskey had the work gangs and expertise in doing the necessary tasks. It is said that Kirk Boott contacted Cummiskey in 1822. Boott was the agent for the Merrimack Manufacturing Company being built along the banks of the Merrimack River in the town of Chelmsford, soon to be called Lowell.

Cummiskey, along with about thirty other Irish laborers, walked the twenty-seven miles and met Boott at Frye's Tavern on Central Street. Boott and Cummiskey cemented the deal that was to benefit them both. Boott was to have the labor he needed to build the mills and dig the canals, and the Irish were to have jobs. From the beginning, Cummiskey took on the role of leader. Tradition says that after raising a pint, the crew went to work that day.

Another report recalls the stares of Lowell's Yankee population as it watched the daily parade of these new people carrying their pickaxes and shovels down Merrimack Street toward the Pawtucket Falls. At night, they would set up their tents and crude dwellings close to their work areas, some being reported along Tilden Street. Later, a barn would be used as more workers arrived. These camps would be scattered sporadically throughout the area, outside the new brick-and-mortar factories and boardinghouses for the Yankee mill girls. A swampy grove of trees and brush separated the new growing utopia from the Irish camps. The increasing number of Irish began to segregate themselves into groups by old-country county identifications. Work gangs formed based on members' county of origin in Ireland, and as more county men arrived, the gangs grew. This can be shown by early naturalization records; for example, Tyrone men sponsored other men from County Tyrone. The Yankees began calling this mix of shanties and crude huts the Paddy Camps.

HUGH CUMMISKEY, GENTLEMAN

LOWELL DAILY COURIER, *Dec. 14, 1871—Another Old Citizen Gone*

Died at his residence on Adams Street in this city on the evening of the 12, Mr. Hugh Cummiskey, aged 82. Mr. Cummiskey was born at Dromore, in the County of Tyrone, Ireland, and came to this country in 1817…Mr. Cummiskey has always borne an excellent character, and been highly esteemed both by his own countrymen and others. He leaves a widow to whom he was married in 1821, and five daughters.

The funeral will take place at 3 pm tomorrow, at the house on Adams Street.

The death of Hugh Cummiskey brought an end to an era. It can honestly be said of him that Cummiskey helped mold and shape Lowell's Irish community from its earliest days. The likes of him would never be seen again.

Born about 1794 in the township of Crossan, County Tyrone, Northern Ireland, Cummiskey came to Boston, Massachusetts, in 1817 and settled in Charlestown. There, he quickly became a leader of work gangs. He also ran a brewery located next to the navy yard. Records show him making contracts and paying laborers out of his wages. His reputation grew.

Noting the need for stability among his native Irish, he was part of the group that requested a permanent priest to be stationed in Lowell, leading to the building and dedication of St. Patrick Church in 1831. He was also among the first to buy lots after the establishment of the Catholic Burial Ground, St. Patrick Cemetery. He was noted by the *Pilot*—a Boston Catholic newspaper that would be a source of news and information for the early Irish—for his work in helping fellow Irishmen to obtain their citizenship papers, as he had done so himself in 1820. He was part of the Hibernian Moralizing and Relief Society, which aided new arrivals.

It was not only among his own people that Cummiskey gave so tirelessly. When President Andrew Jackson visited Lowell in 1833, Cummiskey was part of the welcoming committee. He was made a constable with the responsibility of helping to keep the peace in the camps. This may have had something to do with the fact that the Yankee constabulary had not been very successful. He was a member of the board of health, perhaps having to do with the poor conditions of the Acre.

His expertise as a worker and leader preceded him wherever he went. Contracts trace his labors to Manchester, New Hampshire, and Lawrence, Massachusetts. He considered himself friends with the likes of Paul Moody and Luther Lawrence, early Yankee entrepreneurs. His position of "foreman" gave him the slight financial advantage of earning three dollars per day, more than his compatriots. As time passed, he opened a dry goods store on Lowell (now Market) Street. The lane next to his shop that ran between Merrimack and Lowell Streets was named Cummiskey Alley. The sign is there today. He was part of the rising Irish middle class, but unlike his comrades, he always made the Acre his home. He never left his roots for the newer, more fashionable neighborhoods that were spreading out in the growing industrial city.

As time passed, the aging Cummiskey passed the role of leadership on to others. He is mentioned in myriad lawsuits for nonpayment of bills and eventually declared bankruptcy.

Five children were born to Hugh and his wife. Two became religious sisters; two others were teachers in Lowell. His only son, Patrick, died as a youth. Census records show a multitude of Cummiskeys appearing in Lowell, undoubtedly family members who had followed Hugh and the possibility of finding work. Back in Crossan, Northern Ireland, there are no Cummiskeys today. The line died out in the nineteenth century.

The idea of his obituary being published in the papers when he died in 1871 was a mark of respect to the man. Even at this period of history, an obituary for an individual, especially an Irishman, was not common. A few years before his death, he listed his occupation as "gentleman." Probably there is no truer definition of the word.

As you enter Yard One of Saint Patrick Cemetery, you immediately notice the old slate-and-marble markers, most of them laid flat over the generations. A clearing among the stones, devoid of any marker, was the resting place of Hugh Cummiskey. History does not record why his grave lacked any monument. Perhaps it was by choice. Possibly vandals, age or nature removed the stone. More recently, his grave was located, and an appropriate marker of the type used in his lifetime was placed above his and his wife's remains.

THE PADDY CAMPS

There is an Irish Village nearby that realizes in wretchedness and poverty, every description, no matter how exaggerated, which travelers in Ireland have ever given us—Huts on boards elevated by mud, chimneys with barrels with mere apertures for windows—and then the filth within. Women with faces indicating the free use of ardent spirits, with shrill voices, never uttered but to reprimand and the scores of urchins that squall about you like so many vivified inhabitants of the mud, they delight in, are sufficient to put to rest all our romantic emotions and remembrances of Hibernia, the Isle of "Sweet Erin." These Irish are however but seldom employed in the factories having a better reputation for hard drinkers and good fighters, rather than for industrious workers.
—Ohio Sentinel, *August 20, 1829*

The observer who passed through the town of Lowell that year had high praises for the industrial city that had been built and for its female Yankee employees and agents but not for what was seen beyond the utopia being built. He was not alone. The *Portsmouth (New Hampshire) Journal* of 1831 wrote:

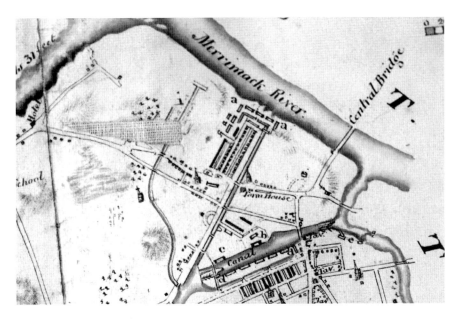

Detail from Hales Map of Lowell, 1831. *Courtesy of Massachusetts Archives.*

In the suburbs of Lowell, within a few rods of the canals, is a settlement, called by some, New Dublin, which occupies rather more than an acre of ground. It contains a population of not far from 500 Irish, who dwell in about 100 cabins, from 7 to 10 feet in height, built of slabs and rough boards; a fire-place made of stone, in one end, topped out with two or three flour barrels or lime casks. In a central situation is a school house, built in the same style as the dwelling-houses, turfed up to the eaves with a window in one end, and small holes in two sides for the admission of air and light. In this room are collected together perhaps 150 children.

The living conditions of the Irish must have greatly contrasted to those of their Yankee counterparts. Many years later, a Yankee named George Hedrick recalled that pigs roamed the streets in the Paddy Camps and were called in at night. Mill girl turned author Harriet Hanson Robinson detailed in her diary: "These women, as a rule, wore peasant cloaks, red or blue, made with hoods and several capes, in summer to 'kape cool,' and in winter 'to kape warrum.'" She also wrote of the brawls between the two populations that were so frequent when the mills were let out of work. The Irish population represented a threat to employment and to the status quo.

An early encounter between a local Revolutionary War hero and the Irish took place in 1822. Captain John Ford was one of the most respected citizens living in this part of East Chelmsford (Lowell would not be named a town until 1826). He was a hero of the American Revolution, having led the Minutemen of Chelmsford back in 1775 and being present at the Battle of Bunker Hill. He was a tall man, wiry and always ready to work. Following the war, he bought a parcel of land down by the Pawtucket Falls and set up a sawmill with a house nearby. He was known on occasion to wear his old army coat with large brass buttons. Captain Ford was proud of his war record and probably sat with his friends at Moses Davis's tavern, now called the Spaulding House, to swap stories. He often told the story that upon arrival at the mill one day, he saw an Indian who proceeded to attack the captain with a knife. Luckily, he was wearing his coat with the large buttons, which deflected the blows. The captain took a metal bar and struck the Indian. Dead, he fell into the sluice way of the mill and down the river.

Was the captain merely spinning a good yarn, or was he telling of actual events? What does the story say about the good captain? The next event may tell us more about him.

Things came to a head for Captain Ford in the fall of 1822. An early biographer, C.C. Chase, in 1891 wrote, "His patriotism was sadly shocked when hundreds of Irish were first brought here to dig our canals."

The hero of the American Revolution might have seen this as a foreign invasion. The war against the British was still alive in the memories of much of the population. The changes that were taking place did not fit with the captain's ideals of why he served. Chase noted, "On one occasion when he could not refrain from indulging in some angry, disparaging words in their hearing, they fell upon him and beat him severely and dangerously." According to his family, the beating hastened his demise. He lingered for two months, passing to his reward on November 6, 1822. The services were widely attended, with the old Chelmsford militia accompanying him to his grave. His remains are in the little cemetery on Mammoth Road within hearing distance of the falls where he spent much of his life.

"GET A PRIEST"

One evening at supper, according to tradition, Boott asked his Irish housekeeper: "What is the matter with those Irish countrymen of yours up in the camps, Mrs.

Winters? Why are they always quarreling and raising disturbances?" And his housekeeper is said to have replied: "Well, Mr. Boott, those countrymen of mine will continue to fight and drink and be bothersome until they have a priest to steady them. What they want more than anything else is a priest and a church!" Some few weeks later, probably as a result of this conversation, Boott arranged with the directors of the Merrimack Company for the loaning of the company's schoolhouse to the Catholics whenever they were visited by a priest in the course of his missionary journeys.
—Irish Catholic Genesis of Lowell, *O'Dwyer, 1920*

The Irish living in the Paddy Camps were a feisty bunch. Many males were there without children and spouses, and weekends could prove a touchy time for the constabulary of Lowell. The area along Lowell (Market) Street, away from the center of town, had a reputation for drunkenness and rowdiness. The dialogue between Mr. Boott and Mrs. Winters might or might not have happened as O'Dwyer claimed, but it is known that Kirk Boott sent to Bishop Fenwick of Boston for a priest. Father John Mahoney arrived from Salem, Massachusetts, to periodically say Mass for the three hundred or so Irish living in Lowell. Fenwick visited the area after Mahoney's suggestion and, along with Boott, agreed a church would be built for the betterment of the Irish. About an acre of land was given to build a church, but Fenwick's troubles were far from over.

THE RIOT

The story depends on whose side you hear it from. The scattered camps were now growing and merging into a neighborhood with names like Cork and Dublin Streets, Cummiskey Alley and Connaught Lane. Shops were springing up. Houses of various dimensions were being built for the Irish. Some were "ten footers (so named because of the dimensions of the dwelling)," others row houses and still many roughly constructed out of any material that was being found. There was a small rising almost-middle class, but the majority lived in hovels and shanties. The Irish were putting down roots. Some say there were outsiders in the town who felt that American jobs belonged to Americans and disliked the new immigrants when the trouble began. Others felt it may have been caused by the Irish, who would go about finding wood scraps to use for their fires, but either way, it came to a head in May 1831.

Accounts vary, but some of the Irish claim that as their womenfolk (some say children) were going through town, certain individuals made disparaging remarks toward them. The Irish husbands in return made their way into town looking for the perpetrators. Members of both groups began hurling insults and more at one another. Rumor had it that the Yankees made threats to enter the Paddy Camps and burn down their houses or their church, which was nearing completion.

The so-called riot took place over Tuesday and Wednesday nights, May 17 and 18, 1831. The Yankees "blackened their faces" while the Irish prepared for the onslaught. Crossing the stone bridge on Lowell (Market) Street, the Yankees attempted to enter the Irish encampments. A mêlée ensued, with the Yankees retreating into the town center. Throughout the next day, both sides continued preparing for the evening's attack. According to some accounts, "hundreds" of Yankees prepared for the next advance while the Irish spent Wednesday attempting to buy gunpowder. Town officials made themselves known and broke up the two groups while arresting a number of rioters.

Newspapers throughout the region carried the story of what was happening in Lowell, some with gross exaggerations and one including a report that a child had been killed. One Irishman, John Hennesey, was arrested and sentenced to ninety days. Three "townsmen" were arrested—Ivory Williams, Samuel Brown and Robert Smallcorn—with similar sentences.

While Lowell's reputation may have been bruised by all the news accounts, another interesting note must be included. In the local papers, articles appeared condemning the acts of the previous week. While they noted that rioters should be brought to justice, they also called for fairness for the Irish. It was openly said that they (the Irish) should be given the same rights and freedoms that anyone who came to work and offered to be a citizen of this country should enjoy. This offer of an open hand was not shared by everyone, but the voice was loud and clear.

DEDICATION

Bishop Fenwick of Boston could no longer ignore the calls from Lowell's Catholics to build a church. Father Mahoney's infrequent visits were not enough to satisfy the needs of the nearly five hundred Irish living in Lowell. The community needed a permanent place of worship for its sacramental requirements, and Fenwick desired to take control over his flock and provide

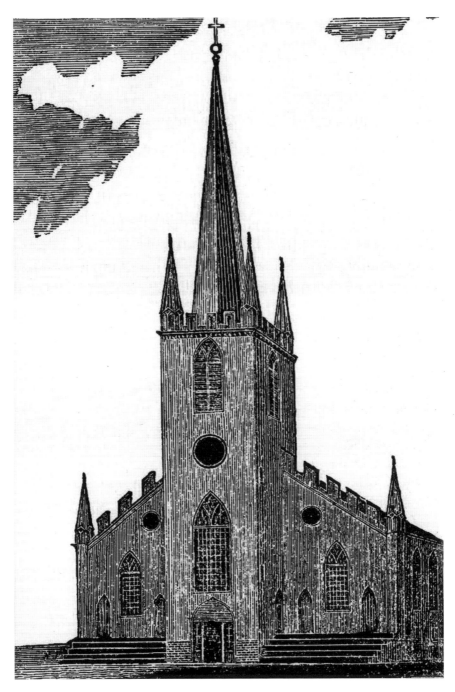

The original St. Patrick Church, 1831. *From* Irish Catholic Genesis of Lowell, *George O'Dwyer.*

a sense of order. Fenwick always walked a fine line between keeping Boston Brahmins happy and being the shepherd of his flock.

Kirk Boott and Fenwick met in 1830 to discuss plans for a place of worship for the Irish. The placement of the church probably was quite intentional since it was between two different Irish settlements: those from the north and the south of Ireland, who often had conflicts between them back in the homeland. From Fenwick's diary:

> *The Bishop this day performs the ceremony of dedication of the Catholic Church in Lowell, under the auspices of St. Patrick. The Very Rev. Dr. O'Flaherty preaches on the occasion & the Rev. Mr. Mahoney celebrates Mass. An immense concourse of people attend* [sic] *of all denominations, as also many Catholics from Boston. The large open space around the Church is literally covered by those unable to obtain place in the Church. The Choir is conducted by singers chiefly from Boston who volunteered on the occasion. In the afternoon the Bishop administers the holy sacrament of Confirmation to thirty nine* [sic] *persons. The weather is excessively hot. The Church at Lowell is 70 feet by 40 & is neatly finished in the Gothick* [sic] *style.*

By the time the church was dedicated, it was already too small to accommodate the growing Catholic population. Father Mahoney was made pastor, and immediately, plans were made to make additions to the church. If the bishop thought things would quiet down in Lowell after the building of St. Patrick's, he was sorely mistaken.

THE CATHOLIC BURIAL GROUND

With the Irish becoming a permanent fixture in Lowell, new problems would arise, one being where to put their dead. Being Catholic meant being buried in consecrated ground. Boston provided the next available consecrated ground. The trip between the towns was a long one, about forty-five miles. Driving a carriage along mostly unpaved roads that were dusty in the summer, muddy in the spring and fall and frozen in the winter made the journey arduous no matter what season you were called on to go, and if Denis Crowley was carrying a double or triple load of the deceased, well that just made his day. Sure there were some places where the road

was paved and even cobblestoned, but those were the exception. Work was work; it paid the rent. Besides, he was performing one of the corporal works of mercy. Surely the good Lord would look kindly on him when it was his time to meet his maker. It was Denis Crowley's calling to bring Lowell's Irish Catholic departed to the consecrated burial ground of St. Augustine's Cemetery in South Boston. Sometimes, he would have to continue on and drive his wagon up the hills of Charlestown all the way up to Bunker Hill Cemetery, where Irish Catholics had just been given permission to bury their dead by Boston's city fathers who had earlier denied burials to Catholics.

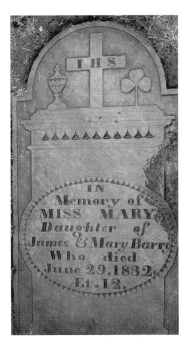

The grave marker for Miss Mary Barry, 1832 (note shamrock design on stone), St. Patrick Cemetery. *Author's collection.*

That was fine until the city fathers of Boston saw their burial grounds being filled up too quickly and made the decision that outsiders would no longer be given the privilege of being interred in either Catholic cemetery.

The Town of Lowell kept two cemeteries in the area, one being along Boston Road (Gorham Street) known as Number Two. The Irish may have started putting their dead in a tract of land that runs parallel to Number Two, now called Old English Cemetery. There is one stone in St. Patrick's that gives the date of 1829, three years prior to the cemetery's formal establishment. It seems certain that the stone was placed there much after the burial, and whether the burial was at that place is questionable.

In the notes of Bishop Fenwick for April 10, 1832, the following appears: "A day similar to yesterday. Rev'd Mr. Mahoney arrives from Lowell & states that a burying ground has been purchased close to town on the road to Bilricky & that it is in every respect a desirable spot for the internment of the dead. He states farther [*sic*] that Kirk Boott Esq'r has given another Lot fronting the Cath church for their better accommodation."

For many years, the place was known as the Catholic Burial Ground; only later would it be called St. Patrick Cemetery. The earliest stones were certainly carved by the Yankee stonecutters who could be found listed in the

earliest town directories. The names of Benjamin Day, Thomas Warren and David Nichols can be found at the base of many stones. The iconography of these stones followed the Yankee pattern of willow and urn that can be found all over New England in this period, but in Lowell, a striking difference happened. The Irish began to add crosses and other Catholic symbols to the slate stones. Most interesting are a number of slate stones carved with shamrocks, some little resembling the actual plant in more of a folk style. Why these stones were being carved or who the actual carver was is unknown. The reasons for the ornamentation might have been for religion or national pride or to make a veiled statement that the Irish were here to stay. No other stones like these from this period have been found anywhere else. The inscription on these stones often give genealogists much-needed information since they frequently contain county, or even town, of birth and often a cause of death. The cost for such a stone would far exceed most workers' wages. Having a number of slate stones in the area shows the existence of a small but possibly growing middle class or trade population of Irish. The common worker of this period would have dug the grave of the family member themselves and erected a simple wooden cross to mark the spot.

Obviously, not everyone approved of a Catholic burial ground. Shortly after the burning of the Ursuline convent in Charlestown, Massachusetts, the burial ground at Lowell was desecrated by a large number of wooden crosses being pulled up and broken.

THE HOUSE ON GORHAM STREET

The Acre, where most of the Irish lived, was not the only section of Lowell to witness the Irish invasion in the 1830s. A growing number of Irish were moving into the area around Gorham Street. Similar to their fellow Yankee counterparts in the Acre, the Yankees along Gorham Street were not too welcoming to their new neighbors. As a matter of fact, the summer of 1832 became quite turbulent in August between the two factions.

It appeared that the locals were not happy with the affairs on Gorham Street. The loud noises and brawls brought out the constables, who counted seventy-two persons living in just half of a house. "Their want of cleanliness invites pestilence" was the quote from the newspaper. The decision was made that all inhabitants would be removed from the house, but the Irish had a different idea. They refused to move.

Rumors spread that a number of guns were kept in the house. On the second night, a crowd of about eight hundred gathered to witness the attempt to evict the Irish. Stones were thrown, and two Irishmen were knocked down. The pleas of the constables were finally heard, and the crowd dispersed when it saw there would be no more action that evening. Five people were arrested. Bail was set, and the accused were to appear at court in Concord. Some put the blame solely on the "Irish population who do not know how to conform to Yankee regulations."

When September rolled around, the Irish were still in the house. One of the young residents fell into a sewer and almost drowned. A terrible "pother" was raised in fear that the little "darlint" may die. Twenty Irish women gathered and "howled" loudly while the child struggled for his life. A "stout Paddy" climbed down and dragged the child out by the heels, decreasing the probability of the "number of tenants in the house being lessened by one."

The weather that Lowell experienced in January 1835 was "unprecedented." The low temperature recorded that month was twenty-four degrees below zero. The freeze was up and down the East Coast, closing ports as far as New York because of the ice. People were found frozen to death in their homes. One poor soul went out to the stable to check on his horse and froze to death there. Fires were breaking out with people trying to keep warm and becoming careless with their stoves. Some hardy souls were foolish enough to throw ice parties out on the frozen rivers. It was well known that many used it as an excuse to imbibe strong spirits.

Maybe the cold was what drove six-year-old Michael Mangin over to Goodhues and Brooks on Hurd Street. Artemas Brooks operated a small shop where he employed a few workers shaping wood to be used as molding and other decorations. The sharp planes were dangerous, but living in an industrial city like Lowell in 1837, one was constantly surrounded by such potential hazards. Michael possibly lived about one block away on Green Street, where many other Irish found housing. He was actually a familiar figure in the shop. He often came here to pick up wood chips to bring home to be burnt. There are a number of accounts of Irish gathering wood pieces to be used for fuel or for building their shanties.

It was just before sunset on this particular day when Michael appeared with his little collecting basket. He and two friends went about the shop gathering scraps. Surely his mother sent him out to the shop before it closed and before his father came home, maybe from the nearby Hamilton mill. With the extreme cold, she wanted to be sure she had enough to keep the fire going on this cold winter night. It took one second for the accident to

happen. Michael lifted his head into the turning blade. The sad details were listed in the paper, as nineteenth-century writers loved to narrate. He took but a single breath and expired.

One can only imagine Artemas Brooks carrying Michael home, the cries of the mother, the family gathered at the Catholic Burial Ground.

The *Boston Courier* of August 27, 1841, reported that before midnight on Thursday, August 26, a great fire took place in the Acre section of the city: "Five entire blocks of wooden buildings and parts of others were consumed." Workshops, furnishings and tools were also destroyed. "About 50 poor families were burnt out, losing the greater portion of their furniture and effects," the paper noted. The most tragic detail of the story was the death of a Mrs. McLaughlin and her infant child, who were buried under the ashes. The conflagration took place near the Catholic church on Suffolk and Fenwick Streets. Beyond the loss of human lives, another entry detailed the loss of several animals.

The Lowell papers corrected the errors made by the *Boston Courier* report. No human lives were lost. The dog that died actually ran back into the house after being rescued. The paper stated, "We have not learned his name, but believe it was Bose. His master says he was a good dog." The other animals were pigs that "had been converted into roast pork." Actually, one pig leaped out of the attic window of one of the houses.

Five blocks were not burned, but two houses and four "ten-footers" were destroyed. Much of the furniture was saved, but it was also noted that the families who were affected were those "of little property." The *Courier* lists the names of those who suffered loss by American families and then by Irish families. The following days' reports also state that the fire department had a difficult time fighting the fire since the canal had been drawn down and it was very difficult to get water to the flames. Large stones lined the canal, and an engine had to be lifted over the rocks to the canal's edge to get the needed water. A committee was formed by some concerned citizens, among whom were the Reverend James McDermott and Hugh Cummiskey, to help the unfortunate victims. It was hoped that the sum of $800 could be raised in the churches that Sunday.

Squalid living conditions, fires and cold were not the only problems besieging the Irish. They also had to contend with themselves. The years 1832 and 1833 were wrought with accounts of the Irish quarrelling among themselves. Many years later, a prominent Yankee, George Heddrick, wrote in his recollections in *Contributions of the Old Residents Historical Association*:

When the canals were being dug, a large number of the citizens of the Green Isle were brought here for that work. On what was called "The Acre" (now Cross Street and vicinity), there stood an Irish village, with the real Irish cabins and shanties, built of boards, sods and mud—such as can be seen in Ballyshannon, if any of the Lowell people ever happen to go there. Outside were the chimneys, built in a half circle, of paving stone, topped out with flour-barrels, for the smoke and for ventilation. Each cabin had its piggery attached to its side; and the Irishman thought of and cared for his pig as much as George E. Mitchell, of porous plaster fame, thinks of and cares for his smart horse. The streets in this village were just wide enough for the quadrupeds to play with each other, when they were let out of the piggeries, evenings, for that purpose; and as the young Celts chased them, to get them back to their styes, as was often the case, there was some lively music in that district.

It was so bad that John R. Adams Esq., a prominent Lowell figure, wanted "to remove the Irish by force from their present settlement." However, other citizens disagreed, writing in to newspapers that the town would end up paying for the expense of the expulsion if it took this course of action. Lowell newspapers ran tidbits showing the common perception of the Irish, such as this one from the *Lowell Mercury*, that helped foster anti-Irish sentiment: "A Real Hibernian—An Irish mason walking along with a hod on his shoulder, perceived a receipt book fall from a gentleman's pocket just before him. Paddy picked it up and, observing a note sticking between the leaves, took it himself before calling very honestly after the owner: 'Now halt a bit man, see here's ye book that ye dropt on the pavement, but somebody has stolen a fifty dollar bill out of it.'"

In June 1833, two nights of fighting between Irish groups and police trying to evict some renters took place, with bricks being thrown and Hugh Cummiskey, who had been appointed constable, shot in the hand. "Windows were broken and some black eyes and bloody noses were exchanged," the *New Hampshire Sentinel* of August 30, 1832, reported. "They have had much trouble in Lowell with the Irish population who do not know how to conform to Yankee regulations. This class are in a very crowded state, and disposed to be rather turbulent with all."

On the surface, one would assume the Irish to be the sole cause of all the troubles. To some degree, this was true. The Irish did very much stay within their old-county boundaries from back home and brought their rivalries with them. But there were other factors as well. The land the Irish had pitched

their tents on was now in the middle of a court dispute. While some might be considered squatters, others had been paying rents. The case eventually went to the Massachusetts courts. The fear of job security for both Yankee and Irish was very real and was another potential cause for the outbreaks. No matter what, they were here to stay.

LEWIS HINE'S PHOTOS

In the early 1900s, Lewis W. Hine traveled across America recording child labor practices that occurred in the mills of the North and South. His work is a window into the past and allows us a glimpse of life in industrial Lowell at the turn of the twentieth century. The following are just a small part of the photos he took while in Lowell, Massachusetts. All photos and text are from the Library of Congress collection.

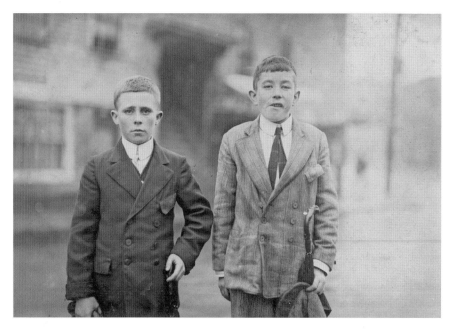

Cornelius Hurley, right end of picture, 68 Adam Street, been at work in No. 1 Mill room in Merrimac Mill, Lowell, Mass., for six months. About 13 or 14 probably. Michael Keefe, 32 Marion Street been at work in No. 1 Mill room Merrimac Mill. Location: Lowell, Massachusetts.

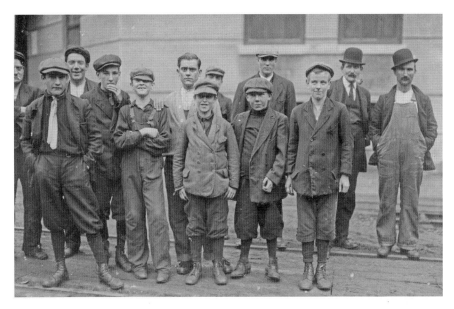

Dennis Cavanaugh, 24 Bassett St., works in spinning room No. 6. Door boy is Alexander Stankiewicz, 3 Fayette Street, Millens' yard. Works in lower spinning room No. 2. Been there 1½ years. Appears 12 or 13 years old. Mass. mill gate near Bridge Street, Lowell, Mass. Location: Lowell, Massachusetts.

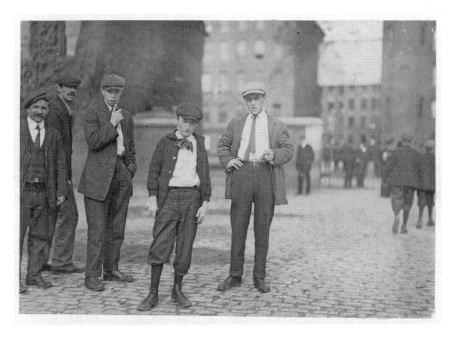

Smallest is Michael Lynch, 20 Brooklins St., works in Twisting Room, Merrimac Mill, Lowell. Location: Lowell, Massachusetts.

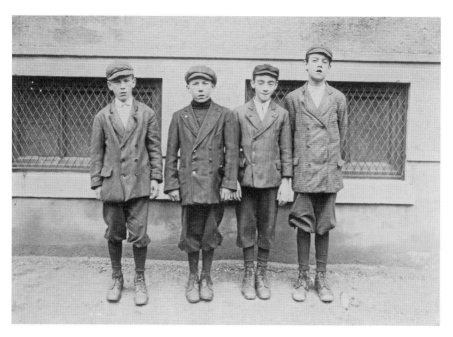

On left end of picture is Thomas Kelley, 275 Lakeview Avenue, has been doffing in lower spinning room No. 2 for one month. Appears 12 or 13 years. Next to Thomas are Patrick and Walter….Next to right end is Luke Gray…Right end John O'Donnell, 8 or 9, been doffing in spinning room No. 1 over a year. Is over grown but may be 13. Location: Lowell, Massachusetts.

Part II

SETTLING IN

*That original number of 30 laborers walking up from Charlestown in 1822
rose to about 500 by 1830 according to Bishop Fenwick's accounting. During
the period of the Irish Potato Famine the Irish population of Lowell would rise
to approximately 9,000 out of 30,000 inhabitants. That number would further
increase to about 11,000 making the Irish a third of Lowell's population.*
—Ethnicity in Lowell, *Forrant and Strobel, National Park Service, 2011*

That first wave of pioneer Irish who settled the Paddy Camps and the
area of Chapel Hill was slowly giving way to the next wave of Irish
immigrants. Lowell was the destination where work could be found and a
community with which the settlers could identify. With the growing numbers
came new problems and new leadership. The country was also aware of the
growing number of foreigners coming to America's shores. Not everyone
welcomed them with open arms. Not all of the problems the Irish faced
came from the outside. Old clan ties and affiliations continued across the
pond. Decisions had to be made on how Irish or how American one had to
be and how one would prove such when the time came. A growing middle
class of Irish tradesmen also had their vision of how the Irish community
would be run.

THE IRISH BENEVOLENT SOCIETY

It was not uncommon in the 1830s for larger cities to form aid societies to help the poor, especially during winter, when the cost of buying fuel could mean the difference between life and death. By this time, Lowell had reached that point, and many of the Protestant churches took up collections to assist Lowell's needy. It was noted in local papers that the Irish were by far the recipients of the society's resources. In 1835, Reverend Peter Connolly, curate at St. Patrick Church, was commended by the Lowell Fuel Society for helping raise money to buy wood for the Irish poor.

Also by this time, a small but influential group of middle-class Irish were beginning to plant roots. While the great majority worked in the building of the canals and red brick mills, a few started becoming tradesmen and landowners. Whether by guilt or altruism, the Hibernian Moralizing and Relief Society was formed in 1833. Made up mostly of tradesmen and those with growing finances, from its name one can assume that the group would do much to help its own. How much it helped the poor is unknown, though the town did grant it the use of a meeting space because of its good works. It seems the society was as much a social club as a relief group.

The name was changed to the Irish Benevolent Society (IBS) about 1835. The idea of it being benevolent might not have agreed with Bishop Fenwick of Boston. Led by the likes of businessman Charles Short, liquor dealer Owen Donohoe and real estate agent Stephen Castles, the society tried to use its influence in church affairs. At one point, the IBS requested that the bishop give it total control of the weekly collection and to only send a priest to attend to the sacraments. The bishop did not approve this request. While the society was surely a thorn in Fenwick's side, it held the purse strings.

Throughout its tenure, the IBS was the organization Irishmen joined if they wanted to show they had made it in America. By the later half of the nineteenth century, the membership list had reached several hundred. It was composed of Lowell's most prominent Irish politicians, physicians, lawyers, businessmen and tradesmen. To have the name of the Irish Benevolent Society listed in your obituary meant something.

Beginning in 1835 and for almost every year until the first years of the twentieth century, the Irish Benevolent Society led or marched in the annual St. Patrick's Day parade. It hosted dinners and dances, cake walks and variety shows. It brought in speakers promoting Irish emancipation and through these annual speeches promoted the ideal of being both Irish

and American. One of its major annual events was the annual "wash out." At dawn, a parade of horns and drums would march throughout the Acre neighborhood, through downtown Lowell and down Gorham Street announcing the trolleys were loading to go to the beach. Participants would carry American or Irish flags. For some of Lowell's Irish citizens, it was their one chance a year to have a day off and swim in the ocean.

As membership grew, the society had to change meeting halls to accommodate the growing numbers. Its hall on the corner of Gorham and Appleton Streets was replaced by a five-story building on Palmer Street. Toward the end of the nineteenth century, membership began to wane as the older generation died away. There were attempts at resurrecting the group, but it never regained its prominent status, later being replaced with other societies.

THE DAY WE CELEBRATE

So begins the opening line of the first-recorded celebration of St. Patrick's Day in Lowell. A *Lowell Mercury* edition of 1833 gives us a picture into the past. All the major leaders of the Irish community were at the Mansion House. Mr. Blanchard, the owner of the establishment, served a fine supper. He was known for his oysters and setting a fine table. They were a close-knit group, a tight band of "native sons" who were making new lives for themselves. Of course, there were Hugh and Eugene Cummiskey. Hugh's close friend and business partner, Samuel Murray, was also there. At the head table was Charles Short. He seemed to be involved in everything in the Paddy Camps—land dealings, business arrangements and even causing the bishop some grief with choosing a new pastor (but that wouldn't be until a few months after this meeting). The Campbells came in, one a tailor and the other a laborer for the mill corporation. They were among the growing number of businessmen in the Acre. Most of the crowd, which was composed of solely men, made its way over from Lowell (Market) Street and Fenwick Street. There were teamsters, carpenters, real estate agents and stable owners. They were here to show their fellow Irish countrymen that America had much to offer.

After the tablecloth was removed, the musicians—and they were a fine group by all accounts—started up their tunes. Of course, the first was "St. Patrick's Day." They slapped their hands on the tables and prepared the first

round of toasts. "The day we celebrate—may its memory be celebrated in the breast of every Irishman." The glasses were lifted, another jig was played and the sentiments continued. They remembered their homeland and those left behind. They remembered their heroes and cursed their oppressors. They lifted their glasses to O'Connell and the Irish harp. Over and over again, they remembered their new home: President Jackson, democracy, the Constitution, the Merrimac River and the owners of the loom. They sang "*Adeste Fideles*" when they recalled Bishop Fenwick and sang "Yankee Doodle." Music and poetry filled the room. As the night drew late, someone reminded the crowd that it was a Saturday and the next day was Mass. So some made their way to their hacks, and others bundled up and walked out into the March night to return to their homes.

In the words of James Campbell, "May the Sons of Old Hibernia celebrate the festival of their Patron Saint, with mirth, cheerfulness and conviviance."

John Quinn, in 1893, recalled the first parade through the streets of Lowell on St. Patrick's Day 1837. They marched through a heavy snowstorm. It must have been an impromptu event since Quinn recalled that residents had no prior notice, and it appeared that the Irish "were about to capture Lowell." Each year, the festivities got larger and grander with larger parades, other societies joining in and multiple feasts taking place across the city. Early on, the Irish were sure to invite Yankee guests and politicians to join in. They were showing they shared the American ideal of democracy and that they were here to be part of that ideal.

THE BISHOP'S PROBLEM

Benedict Fenwick had a problem. The growing parish in Lowell was composed of upstarts and trouble makers. Being the second bishop of Boston, he had to maintain a delicate balance. He represented the Catholic presence in Yankee Boston. While courting the Brahmins of Boston, he needed to meet the needs of the ever-growing Irish population that stretched from the deep woods and Indian strongholds of Maine, down the to the mill towns springing up along New England rivers, over to the choked streets of Charlestown and to the fishing villages of the Atlantic—all of this with a handful of priests. It meant a different life from his upbringing.

The Fenwick family was one of the great families of Maryland, founded as a sort of refuge for Catholics. He could have had a life of ease but chose

the seminary, specifically the Jesuits. Soon, he was a professor at Georgetown and later a leading prelate in New York City. He was assigned to help heal divisions in South Carolina. Probably because of the success he had there, upon the return of Bishop Cheverus to France, Fenwick was elevated to the rank of bishop. Donning the purple robes of his status, his ecclesiastical ring and crosier, he left to encounter the trials of his new life in Boston.

He was now the prelate for one of the major dioceses in the United States, but he also knew of Boston's past. Christmas, at one time, was banned and still was not fashionable at Fenwick's time. Bonfires and burning the pope in effigy was still being practiced on the fifth of November in remembrance of Guy Fawkes, an English Catholic who attempted to blow up Parliament in the 1600s, though not as violently as in the previous century. The trees that filled Boston Common once held the hanged bodies of his fellow Jesuits in the city's earliest Puritan era. Though many of these practices were no longer observed, there was an underlying bias against anything papist, and with the growing number of Catholics, Boston was on edge.

In 1831, Lowell was his pride and joy. The corporations had offered for purchase land for a church and later a cemetery. The numbers justified a full-time priest, Father Mahoney. The church was dedicated in July of that year with imposing ceremonies. Regular reports were coming in. While the offertory collections weren't great, Fenwick had hopes.

The pastor, Father Mahoney, made frequent trips to Boston. Mahoney "gives an account of a great division which has taken place there between the Catholics of the North and those from the South of Ireland. Whatever one of the parties propose for the good of the Church, the other is sure to oppose it, let it be ever so proper. He knows not how to effect a reconciliation." According to the bishop's diary, he made a visit to see what was happening, hoping his influence would calm the storm.

Meanwhile, Father Mahoney was replaced by Father E.J. McCool. The young curate, Father Connelly, wrote to Fenwick saying things had gone from bad to worse. Fenwick was forced to make several more visits to Lowell only to find little had been done. There was not enough lumber in the city, and Mr. McDonough, the foreman of the work crew, refused to do any more work until payment was made. On top of that, it seemed the new pastor was not much of a shepherd to his flock.

Fenwick made several trips by train and stage to check on conditions. After Mass, he asked the males to stay behind. He found the expansion to the church that he had approved had not been made. The funds that had been promised were not collected. At the meeting, the bishop challenged

the group to sell pews to help pay for the costs of the church's expansion. The muddy roads made the trip back to Boston unbearable, and he did not return home until midnight.

Reports continued to come from Lowell of disorder between different Irish factions, an inept pastor and still no building expansions. He personally sent lumber to Lowell to restart the building. He sent the new pastor on "a spiritual retreat." He closed his diary entry by confessing he had a headache.

THE IRISH SCHOOLS

Leaving Ireland and finding your way from whatever port you landed at and then finally settling in Lowell meant priorities were not focused on educating children. For many, it was all they could do to make ends meet. In Ireland, education for Catholics was a question of morals. By British law, Catholics could not open their own schools. Catholics could attend British schools, but many parents chose not to accept such conditions. To some, this was one way the British would attempt to Anglicize the Irish, which might even lead to conversion to the Protestant faith. In its place, the Irish Catholics formed their own hedge schools, so-called because they met hidden away in hedges—though, in fact, British authorities often knew of these schools and did little to stop them. It is understandable, therefore, that the Irish coming to America would be hesitant to send their children to American public schools, where the King James Bible, not the Latin Vulgate, would be used for classroom prayer and teaching.

There were attempts at starting schools by the Irish for the Irish in the Paddy Camps during the 1820s. Bishop Louis Walsh published an article in 1901 called "Early Irish Catholic Schools in Lowell Massachusetts." The Bishop recounts that the first pastor, Father Mahoney, "opened a school in a two story building, next above Dr. Blanchard's meeting house and placed an Irish schoolmaster in charge." The 1844 School Committee Report tells more about early attempts of educating Irish children:

> By the advice and efforts of philanthropic individuals, a room was rented, supplied with fuel and other necessaries, and a teacher placed in this school who was to be remunerated by a small weekly, voluntary tax from the parents. From the poverty and indifference of the parents, however, the school languished and became extinct. It was revived from time to time,

but after months of feebleness failed. Up to the year 1840 the attempts to establish a school in the neighborhood of the Acre, were sustained chiefly by individual benevolence.

In May 1830, Lowell's school committee took under adoption the idea of opening a separate school for the Irish. In Bishop Walsh's account, he saw this as a way the Yankee population would keep their distance from their Irish neighbors. The school committee report continues: "At the annual town meeting in May, 1830, an article was inserted in the warrant for the appointment of a committee to consider the expediency of establishing a separate school for the benefit of the Irish population. The committee reported in favor of such a school; the report was accepted and the sum of fifty dollars was appropriated for the establishment and maintenance of a separate district school for the Irish. It was kept only part of the time and suspended. All the arrangements hitherto were unsatisfactory." What the committee minutes mean by this statement is uncertain, but the next event might show what the Irish thought about this arrangement.

It was noted in the Committee's notes that Reverend Peter Connolly had opened a classroom in the basement of the church for the Irish Catholic children. The following year, he petitioned the town for aid to keep the school going. Certain conditions on both sides had to be made:

1st—That the instructors must be examined as to their qualifications by the committee and receive their appointment from them.

2d—That the books, exercises and studies should be all prescribed and regulated by the committee, and that no other whatever should be taught or allowed.

3d—That these schools should be placed, as respects the examination, inspection and general supervision of the committee, on precisely the same ground as the other schools of the town.

Mr. Connelly urged, the instructors must be of the Roman Catholic faith, and that the books prescribed should contain no statements or facts not admitted by that faith, nor any remarks reflecting injuriously upon their system of belief. These conditions were assented to by the committee.

In essence, by the terms of this agreement, a Catholic school was being operated with public funds. This collaboration between church and state was not foreign in America, as other growing cities with immigrant populations were finding this a way of accommodating both groups. Lowell was merely following precedents set by other cities.

According to George O'Dwyer, who collected oral histories and created one of the first histories of the Irish in Lowell, Patrick Collins was chosen as the teacher of the school in St. Patrick's basement on June 14, 1835. This Irish school was supervised by Reverend Peter Connolly of St. Patrick's. In 1838, Mr. Collins's school was moved to Liberty Hall on the corner of Jefferson and Lowell Streets, and he was designated master. The school was then known as No. 5 Grammar School. Collins received $262.50 a year for teaching.

It may be Patrick Collins about whom Reverend John Knowles, a member of the school committee during that period, wrote in a reminiscence in the *Lowell Courier* of 1871:

> *The writer paid an official visit to the school there in 1830 when we found the schoolmaster at home in one of those* [Paddy] *camps dispensing knowledge as well as he could. He taught them reading and spelling with the prayers of the Catholic Church. He showed the committee his board—consisting of a half a loaf of bread on a small pine table and a pail of water under the table. He apologized for the frugality of his table but said it was as bountiful as his means would allow. I am glad the modern schoolmaster is seeing better days.*

The program was quite successful, as stated in the School Committee Report of 1838. Over 750 children attended the now five Irish schools, with 6 teachers overseeing them. While that number was not the daily attendance, the report states that the Irish students were attending at the same rate as the other schools in the city. It further reports that the Irish students were given the choice to attend any school near them and that they "have access to the High school on equal conditions." As was the custom in the period, members of the committee would often make visits to schools and test the students on items in the curriculum. Over and over again, the committee reported on the high quality of responses given by the Irish students.

The situation that seemed to be working so successfully took a turn in 1843. A new pastor at St. Patrick's, Reverend James McDermott, became quite vocal about the morality of some of the teachers in the Irish schools. From the pulpit, he named them and further stated that the children should not be sent to school until they were removed. Father McDermott's charges

were never clearly defined or substantiated. It is more likely the priest felt he was losing control over his flock with the building of another Catholic church in Lowell: St. Peter's. Since his arrival in Lowell, McDermott had made it clear he wanted control over hiring only Catholic teachers. He also butted heads with many other Irish in the city, especially the influential Irish Benevolent Society. His rants and raves made news in Boston and all the way to New York. By the 1850s, the city fathers no longer saw the need for separate Irish schools, and they were slowly absorbed into the public school system.

WHEN REVEREND JAMES T. MCDERMOTT CAME TO TOWN

The issue with the school was not the first problem that faced Reverend McDermott. His arrival in Lowell was not what he expected. If Bishop Fenwick thought his earlier problems with adding the church extensions were hard, he would find that the remainder of 1836 and 1837 would be even more difficult. The first pastor of St. Patrick's, Reverend Mahoney, was replaced by Reverend McCool. There may have been some disagreements between Mahoney and his curate, Reverend Connelly. Reverend McCool was not the right choice for Lowell. Very soon, reports went back to Fenwick that McCool was not carrying out his ecclesiastical duties. Connolly sent letters and met with the bishop. The bishop sent various persons to report on the happenings in Lowell. As reported in his diary, "The Bishop writes sundry letters on the Lowell affairs having heard bad news from that quarter." News that Fenwick was appointing a new pastor leaked out. The bishop wrote, "A deputation consisting of twelve individuals from Lowell wait on the Bishop with a petition signed by over three hundred who are inhabitants of Lowell requesting that the Bishop will not remove the Rev. Mr. McCool from Lowell. Stating that should he persist in so doing the consequences might be afflicting." Fenwick nevertheless withdrew McCool to be replaced by McDermott, causing the trouble to boil over.

Having a permanent priest for your church was an honor in this early period. Fenwick's diocese stretched through most of New England with only a handful of priests to take care of matters. But Lowell's Irish sent a veiled threat to Fenwick that they would not accept anyone but McCool. McDermott's welcome when he got off the stage from Boston must have been less than enthusiastic. On September 1, 1837, the bishop wrote:

Rev. Mr. McDermott arrives from Lowell & brings intelligence that the Party of Rev. Mr. McCool headed by Charles Short did cause the doors of the Church to be fastened against him on last Sunday; but that he was able to get in & afterwards celebrated Mass & preached having first caused the doors to be opened. The party is represented as a contemptible one. This act on their part has given the finishing blow; for the Catholic part of the congregation, which is by far most numerous, are filled with indignation at this daring attempt at schism.

Charles Short was a leading member of the Irish Benevolent Society, and the IBS pretty much held the purse strings to whatever happened in the church. Short, and other members of the IBS, were liquor dealers, among other things. McDermott would be well known from Boston to New York as an ardent advocate of the temperance movement. Reverend McCool continued to visit the city and was eventually dismissed from Fenwick's charge. He died in 1839, a broken man. Within two years of McDermott's assignment, he reduced the church's debt by almost half. He may not have been making everyone happy, but he was doing what he was sent to do.

THE OTHER CATHOLIC CHURCH: ST. PETER'S

If the good Lord meant for the Sabbath to be a day of rest, the Irish of the Chapel Hill area might not have agreed. Being Irish and being Catholic meant only one thing on any given Sunday morning: walking almost two miles and back to attend Mass over at St. Patrick Church. And if you were a really good Catholic, you went back in the afternoon for Benediction and Vespers. When St. Patrick's opened in 1831, conditions were already crowded. Extensions were built onto the church a few years later, but with the growing numbers of Irish entering the city, even that was not enough.

In July 1841, Bishop Fenwick came to St. Patrick's to confirm sixty young men and women. The church was overcrowded, and before the end of the ceremony, he asked the parishioners to consider building a new church. At the close of the afternoon service, he stayed to discuss the proposition with interested parties. The excessive heat of the day did not deter the crowd. Forty-two men rose immediately, and each promised $100 to be applied to purchasing their pews once the new church was built. That night, $5,400 was pledged. Yet not everything was kosher.

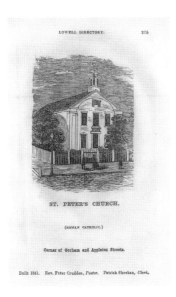

LOWELL DIRECTORY. 275

ST. PETER'S CHURCH.

(ROMAN CATHOLIC.)

Corner of Gorham and Appleton Streets.

Built 1841. Rev. Peter Crudden, *Pastor.* Patrick Sheehan, *Clerk.*

Original St. Peter's Church as it appeared in 1858. *Lowell City Directory, 1858.*

There's something odd about the bishop's story. He said the crowds gave him the idea for a new church, but the next day found him in a carriage scouting out a piece of land he had his eyes on. He appointed the curate of St. Pat's, Father Conway, to purchase the plot as soon as possible. One wonders if something else was going on here. Did the bishop know about the land beforehand? Why was the curate put in charge of the purchase and not the pastor of St. Patrick's, Father McDermott? There were rumors—lots of them. Not everyone liked the good pastor. There were certain financially solvent men who wanted a split. Many of the men who stood that day to support the bishop had homes in the Acre. Why would they pay for a new church? The bishop's notes tell of a number of visits of Father Conway to the bishop's residence. Why? Then there was the visit by several members of the St. Pat's congregation to air their "grievances" about the new church being built and that they would "retard as much as possible the progress." The bishop "remonstrated against the unnecessary noise" and dismissed them.

The Irish of Chapel Hill were about to have their dream come true. For years, they had to make the trek from the area around Central Street over to the Acre each and every Sunday for Mass, holy days of obligation, parish missions, funerals, weddings, et cetera. This other Irish neighborhood had grown and evolved with its own shops, tradesmen and overcrowded tenements, much as the Paddy Camps had. The bishop had finally heard their appeals; the new church would be built.

The day following the bishop's call to male parishioners of St. Patrick's for another Catholic church to be built was a busy one. The bishop hired a carriage, since the weather had cooled considerably, to look at a plot of land at the corner of Gorham and Appleton Streets that had been recommended to him, land that belonged to the Hamilton Corporation. He was determined that the ten thousand square feet were a perfect fit for his needs.

The bishop spent a second night in Lowell. He was invited by Samuel Lawrence for a carriage ride around the city. He was amazed at the growth

Lowell was going through and toured the outskirts that were lined with walls of fieldstone and waves of growing corn. Upon his immediate return, he sent Father Conway, St. Patrick's curate, to purchase the land he had viewed the previous day. His anticipation was evident by ordering Father Conway to make three trips that day to meet the agent for the corporation who could complete the sale; on each, he found the agent was not present.

Two days after the bishop returned to Boston, Father Conway sent a message. The land was theirs. The negotiated price was $0.40 a square foot, with a final cost of $2,000. A building committee made up of Owen Donohoe, John McNulty, Hugh Monahan, Hugh Cummiskey and Charles M. Short began the work of gathering funds and support. It appears that Father McDermott, pastor of St. Patrick's, was not happy with the events. He did not believe a second church was necessary, even though overcrowding was obvious. Perhaps he was afraid of his collections falling off, or maybe it was his ego. McDermott enjoyed the influence he had at St. Pat's, and the addition of another church might take away from that. He voiced his opinion to the bishop and added that of a group of concerned parishioners who had threatened consequences if the building proceeded. The bishop had had to deal with many problems with the growing Diocese of Boston. McDermott was only one of them. The German community of Boston was also making threats about their parish leadership.

Mr. Hall was hired as the architect and drew plans for a brick church ninety feet long and sixty feet wide with a basement and belfry. Ground was broken in September 1841. The final cost of the church was $22,000. The bishop made several visits, watching the progress, and noted in his diary when the walls were finally up. The Irish of Chapel Hill had their first service on Christmas Day 1842. Having no organ, the parishioners formed their own orchestra. Newspapers noted how brightly illuminated the sanctuary was with all the "green festoons." The church would not be completed for another year. The Irish Benevolent Society threw its support, financial and otherwise, over to St. Peter's and Father Conway. The former curate of St. Pat's had long ago "severed" his relationship with Father McDermott. This was evidenced by several visits of Father Conway to the bishop "reporting bad news." The formal dedication of St. Peter's would not take place until September 1843. At that time, pews were being auctioned with prices as high as $192 and some even higher. It was clear St. Peter's would soon rival St. Pat's.

Shortly, the offertory collections became far greater than those of St. Pat's, as did the number of weddings and baptisms performed. When the bishop visited Lowell, he often stayed at St. Peter's. Father McDermott's star began to fall quickly.

Life on Gorham Street

A second Irish settlement began evolving in Lowell's early years. By the 1830s, the area around Chapel Street and Gorham Street took on its own Irish flavor. Just like their neighbors, the Irish on Gorham Street opened their own shops and eventually had their own church. After your shift at the mills ended, you'd walk up Central, doffing your cap as you passed St. Peter's and maybe stop by one of the shops before going home.

Philip Haggerty and his wife were well known in the area. Both Irish natives, he was known for his fine singing voice and she for playing the organ. He sang not only in every Catholic church in the city but also in those for almost every other denomination. If there was an event, he was there to sing. He was known to walk along Gorham Street greeting folks right up to the end of his one hundred years.

James H. McDermott began by working with Terrence Hanavor cutting wood for making caskets. Being a good Irish son, Hanavor lived with his mother and never married. He was a member of the Irish Benevolent Society. Upon his death, he left $500,000 and real estate holdings.

If you did your shopping at McKearney's, he would be sure to deliver your groceries for free. He advertised English breakfast teas and fine meats. He belonged to the Irish Benevolent Society, the Ancient Order of the Hibernians (AOH) and the Foresters. Maybe it was on one of these deliveries that he caught cold and died of congestion of the throat. Two hundred friends and families walked from St. Peter's to the cemetery.

If you were trying to get family members over from Ireland, Sheahan and his brother were there to help. Tickets started at $27.50. His shop was directly across from St. Peter's Church. There you could buy tickets for the dedication of St. John's Hospital. He arrived with his family during the famine years from County Clare, where he worked in the grocery business. He must have worked very hard since he retired after working twenty-five years. He was a devoted parishioner of St. Peter's.

Besides operating his store, James Owens worked diligently for the Naturalization Club. An Irish native, he took his American citizenship seriously and helped over nine hundred people attain citizenship. He was a strong Democrat and served as an alderman. On the Fourth of July, he joined many other business owners in decorating his storefronts with flags and bunting.

THE ARRIVAL OF THE O'BRIENS

Obviously, Bishop Fenwick had had it with the goings-on in Lowell. Father McDermott's tirade about the hiring of teachers and then questioning their morality put an end to a system that had worked well for the city and the Irish for a number of years. Fenwick's diary of 1847 related that he suspended Father McDermott and replaced him with Father Hilary Tucker. Tucker had no idea what he was walking into. At first, things went well for the Irish-speaking priest. His reports to Fenwick were positive, stating he had bought an organ for the church and gave a parish mission to over 1,400 congregants [?]. The duel between McDermott and the now growing St. Peter's left Tucker in a void. The bishop wrote:

> *Rev. Mr. Tucker returns from Lowell where he officiated yesterday in St. Patrick church. The Catholics of Lowell for many years have been in a very disturbed state and divided into various factions. Many of them seem to have very little religion or faith. This lamentable state of things seems to have originated from the misconduct and imprudence of certain Clergymen who were formally stationed there and have since left the diocese.*

Father Tucker became so ill that he asked for dismissal from his priestly duties and questioned his vocation. After several laments, the bishop reassigned him to Boston, where he made an immediate recovery.

St. Patrick's next entered a period that could be called the O'Brien Dynasty. Eventually, four O'Briens would serve as pastors to St. Patrick's, but more importantly, they would serve the spiritual and temporal needs of their flock. They came just at the time when Irish escaping the potato famine were coming to America's shores seeking refuge and part of the American dream. The O'Briens would be the men to lead them.

The validity of the story is questionable. When Father John O'Brien was assigned to Lowell, he found the fields quite barren. He arrived at the height of the Irish famine immigration, and the Irish community of Lowell was split quite literally between social and economic groups. A lesser man would have fled. When Father John left his birthplace of County Tipperary, Ireland, he knew he had an elder sibling already working in the United States, but the difference in age and distance left gaps between the two brothers. It is told that on a steamer trip to Boston, Father John spent part of the trip with another cleric. It wasn't until

SETTLING IN

Father John was at home at St. Patrick's in Lowell and there was a knock on the door that he realized who his traveling companion was: his own elder brother, Father Timothy.

One can imagine what life in the rectory must have been like when McDermott met O'Brien—two strong-headed men with very different ideas. McDermott actually purchased an abandoned Methodist church on the same block as St. Patrick's, renamed it St. Mary's and took his followers with him. St. Peter's was going strong, and O'Brien was left with a crumbling church and more and more immigrants seeking help. But when the going gets tough, the tough get going.

A MOST MAGNIFICENT STRUCTURE

Once McDermott left with his followers, Fathers Timothy and Michael O'Brien were legated an aged church and an increasing population made up mostly of the poorest Irish of Lowell. The Know-Nothings were still in power, and the Acre was, in the words of a reporter for the *Lowell Courier* who visited the construction site in October 1854, a place "one cannot admire."

The final result was an imposing structure, making it one of the grandest buildings in Lowell. The visitor was escorted by Father John himself. The church was made of stone in the thirteenth-century Gothic style, designed by Patrick Keely. The length of the building was 170 feet. It included a tower that stretched into the air, making it visible from many parts of the city. From floor to ceiling was 70 feet with the width being 100 feet. The church could hold two thousand people. The stained-glass windows, many donated by individuals and societies, were manufactured in New York. One window alone cost $1,000. John Mack of Lowell completed the stucco work of the church, the beauty of which the reporter could find no words to describe. The entire church cost $60,000 to complete, an amazing amount of money considering the circumstances.

Sunday, October 29, was the day of dedication. In order to keep things orderly, admission was by ticket only at a cost of seventy-five cents, a great amount for a working person of the day. The point did not escape the reporter who attended and commented on the rites and ceremonies performed to dedicate a Catholic church. Bishop Fitzpatrick of Boston was the main celebrant, and his homily on Christian unity was pleasing to the

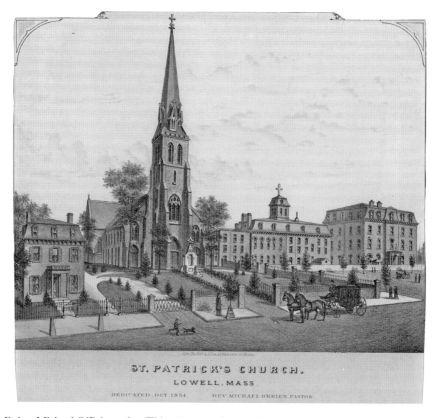

Father Michael O'Brien print. This print was given to Father Michael O'Brien as part of his fiftieth-ordination anniversary celebration in 1899. It shows the church, rectory, girls' school, Notre Dame Academy and convent. *Parish archives.*

reporter. But he did have to make a comment before closing his article. He quoted Shakespeare: "And what art thou, thou idle ceremony?"

This was a remarkable project and challenge to the O'Briens and the entire Irish Catholic community. The dedication of the church was a sign the Irish were here to stay and possibly a message that they would be a force to be dealt with. This was also just the beginning of the O'Briens' dreams.

ILL WILL

The reporter was not the only one who did not approved of the day's events. The church was being built in the same spot as the old St. Patrick's with open

space reaching to Suffolk Street and the Western canal. The owner of the land, it was reported, moved an old "shanty" onto the property and filled it with several families. The property owner? Reverend James T. McDermott. The reporter attributed its placement "to some misunderstanding or ill will."

An article a few days later in the *Courier* gives another account of the happenings. "A Protestant to the backbone" supporter of Father McDermott claimed that McDermott had offered the land at a fair price and was refused. Accusations were made from both sides, and even New York papers picked up the story. Both sides formed allegiances, creating more discord among the Irish.

TEMPERANCE AND THE RUM HOLE ON MARKET STREET

James Gallagher owned a shop on Market (Lowell) Street that sold clothing and accessories. That was by day; by night, Gallagher had another profession: rum dealer. In 1845, upstanding citizens who had taken the pledge asked, "Is there no way Mr. City Marshall that this breathing hole of hell can be stopped?" The rum hole in question was known to openly sell even on the Sabbath!

The history of temperance in the nineteenth century had its ups and downs in the city and the state. To point out Gallagher's as *the* rum hole on Market Street is unfair. There were untold numbers on Market Street and throughout the city. As soon as one was closed down, another would open. The Acre and along Central Street were the most notable places to find them. There were waves of hundreds, even thousands, of individuals in Lowell taking the temperance pledge, followed by periods of quiet tolerance of imbibing. Father James McDermott of St. Patrick and later St. Mary churches was a promoter of the pledge and was noted by Protestant clergy as a model for his people. One of Lowell's premier Irishmen, Hugh Cummiskey, took the pledge and donated money to purchase temperance medals to be distributed to oath takers. Yet a short time later, Rose Cummiskey (possibly Hugh's wife) was caught selling liquor.

The term "drunkard" was used multiple times on a daily basis for decades in the local papers, often attached to an Irish surname. Trying to keep a tally of the numbers arrested and the two-dollar fine plus court costs often attached to it became laborious. In any given month, there

weren't just dozens but hundred. Men were not the only perpetrators. Women were listed as well, sometimes being found passed out in alleyways or having to be dragged out of rum holes. Mrs. Ryan was one of the female operators of one such establishment in the Acre. Repeat offenders could be given a higher fine (three or five dollars), and others were sent to jail. A sad case in the 1850s was that of a father and son repeatedly being arrested for drunkenness and petty crimes. The writer said the son was a "chip off the old block."

Those who frequented such places had to be on guard since there were many occasions of patrons being beaten and robbed. Even innocent citizens passing by had to be aware of who was loitering nearby. Gangs would assault men, beating them and removing their "purses." The perpetrators were often identified as being Irish "ruffians."

What did the citizens of Lowell think? Was this an example of prejudice against the Irish or the reporting of a problem of society at large? There are a number of newspaper articles by Yankee citizens that note the lack of temperance in the city on the part of the Irish. Many of these articles pointed to the Irish population as the problem, citing the decline in the city's morals with their increasing number as evidence. For the counterargument, there were voices that spoke out about the good work being done by the likes of the Father Mathew Temperance Society and other organizations. Added to that, there were voices that said the problem belonged to society as a whole and asked how to address the conditions that could bring about such issues.

McDermott's vocal protests were one of the reasons he lost so many followers. There were those who imbibed, and there were those who produced the goods. McDermott had no problem pointing out who they were and blaming them for some of the conditions of his fellow countrymen. Newspapers, not only in Lowell but also across the country, noted the work he was doing to get drinkers to take the pledge. Even Protestant clergymen of the city commented on his work.

If there was one name in the 1850s that would get the attention of Irish rum drinkers and temperance pledgers alike, it was Father Theobold Mathew. From Ireland to America, there were statues raised to him, medals struck in his honor and societies of thousands who swore off demon rum.

Theobold Mathew and Taking the Pledge, September 1849

Father Theobold Mathew would have been a household name in 1849. An account in an 1846 newspaper reported an Irish wake being interrupted by a dozen drunken Irishmen who assaulted the mourners. The *New Hampshire Sentinel* of 1840 recounts a young girl who said, due to both parents' taking the pledge, "If father earns ninepence he buys a fish instead of rum, as he used to do. They have got a barrel of flour now and mother has a new gown." Time and time again, the pastor of St. Patrick's and later St. Mary's, Father James T. McDermott, was given credit.

When word reached the community that Father Mathew would be making a visit to America, every leading city requested he visit. The priest had become well known in Ireland for his Total Abstinence Society, where members would swear off alcohol, take the pledge and receive a coin as a sign of the commitment. When the announcement came that he was visiting Lowell, influenced by the works of McDermott, there was great planning and excitement.

A poem was published commemorating the event:

No more may the parent
With tottering gait,
In age and gray hairs
Weep a profligate's fate.

From the hands of us all
Thou'st snatched the vile bowl,
That gave to intemperance
Both body and soul.

On the day of his arrival, over three thousand people, along with the mayor, aldermen and, of course, Father McDermott, met the "Apostle of Temperance" at the depot. He was given a tour of the mills, where he chatted with the operatives and even renewed acquaintances with some he knew from Ireland. He gave the pledge to seven hundred at St. Patrick's until ten o'clock at night. The following day, he made his way to St. Mary's and did the same. He was to continue on to St. Peter's, but fatigue overtook him. He was also unable to speak at city hall but still made an appearance.

Tirelessly, the priest kept up this schedule for two years before returning to Cobh (Queenstown), County Cork. He died there just a few years later.

Little did he know that within hours after his departure, the Irish would be involved in the largest riot in decades.

ROW AND FIGHT AMONG THE IRISH, 1849

Sunday afternoon, November 8, 1849, was a day that Lowell would long remember. From its earliest days, there had been troubles between different groups of Irish. The Irish of the Connaught area (composed of the counties of western Ireland) had settled along Lowell and Lewis Streets. Those called Corkonians, from southern Ireland, had settled on the opposite side of the Western canal along Fenwick and Suffolk Streets with only the canal to separate them. The trouble had begun stewing on Thursday evening. Skirmishes broke out several times before the Sunday event.

The *Lowell Courier* recorded the event over several days that November 1849. By evening time, several hundred men, women and children had gathered. "Stones and brick-bats were hurled in a perfect shower, and soon followed numerous reports of guns and pistols, fired from windows and alleys." The mayor and city forces arrived, followed by the fire department, which used its hoses to shoot cold water at the rioters. The city's militia was told to stand ready.

> *The windows of many homes were almost entirely demolished. The long block owned by Stephen Barker, Esq., on the corner of Lowell and Lewis streets and Stephen Castles, block (in which he himself lives,) on Lowell street, suffered badly. Stones of five and six pounds [in] weight were thrown into some of the chamber windows. A pile of bricks, about 3,000, belonging to Mr. Barnard, were entirely broken up and thrown away. Women were seen working like beavers, lugging bricks and stones in their aprons for the contending parties. Even wheelbarrow loads of these missiles were toted round. The streets in all that region are now literally covered with broken bricks and stones.*

There were several arrests, but that did not satisfy many in the city. Much was said about the lack of enforcement by the courts and that the fines of $2 or $3 meant little to the troublemakers. The *Lowell Courier* noted, "A boy

named Patrick Kelley, about 12 or 14 years old, was shot through the body by a ball passing entirely through him. He is alive this morning, but is not expected to survive. Several others were wounded, and it is reported others were killed; but it is impossible to get at the facts, great care being taken by the rioters to conceal them." Stephen Castles, mentioned earlier in the riot and a well-known landowner, was arrested for the shooting. The boy was erroneously declared dead by some news reports, but these were later corrected. Witnesses were called. Many said they saw Castles point a gun out his window and fire. They saw the boy fall and call out he was dying. The case was dropped against Castles since no one saw him aim at the boy and other shots had been fired throughout the evening, leaving the possibility that another stray bullet might have struck him. Twenty of the rioters were brought before the courts with penalties of imprisonment or fines of up to $5,000 imposed.

THE ANNALS, 1852

Father Timothy O'Brien may have been getting on in years, but he still had plans. He knew that if the Irish were going to succeed, the one thing that was needed was education. For two years, he had been asking different religious orders to open a school for the Irish in Lowell. America was very much a missionary territory, and the sisters available to teach were usually in the larger cities. After Father Timothy's requests were rejected by a number of orders, finally a French order, the Sisters of Notre Dame, agreed to send five of their number to open a school. In the correspondence between the priest and superior, Father Timothy promised that he would have everything ready to open the school upon their arrival.

The sisters made their way from Cincinnati to Boston and finally to Lowell. They arrived with two priests. Accommodations were not what they had assumed, as they had to share teaching and sleeping space. The little band found their pantry filled from the meager pickings of their Irish neighbors. Day after day, the doors of the convent would open with people walking in at their leisure.

The opening day of school was September 23, 1852. Since no one in the neighborhood knew when the school would open, the sisters went into the neighborhood with *la cloche* (the bell) to summon their students. The first day, 150 showed up; within three days, there were 300, and the numbers

grew from there. The rule of the Sisters of Notre Dame de Namur said they would teach only girls. Within a week, the sisters had started teaching Sunday school as well. They worked seven days a week. Their superior, Mother Desiree, saw that there were young children in the neighborhood who were unsupervised because their parents were at work, so she opened a sort of nursery to oversee them. Shortly after, the sisters went door to door doing what they could as nurses. Then they were asked by other churches to begin religious instruction for their children. The work was endless.

To fund Mother Desiree's endeavors, she opened an academy that charged tuition. Notre Dame Academy opened in 1853 and continues today in its present location of Tyngsboro, Massachusetts. During Mother Desiree's lifetime, four large brick buildings were built, housing the academy, convent, school and chapel. The convent property was surrounded by a high brick wall to cloister the sisters. Within its confines, the sisters raised fruits and vegetables and kept cows and chickens, which they used for their own food, as well as to give to "tramps" who might call at the convent door. A large grotto of the Blessed Virgin was set in the corner of the garden.

THE ANGEL GABRIEL

"I know nothing." When a member of the Native American Party was asked about this semi-secret political group that was based on American nativism and anti-Catholic bigotry, that was to be his response: "I know nothing." New England in the 1850s was fertile ground for such a group. According to its members, there were too many immigrants and too many Catholics. They infiltrated every level of government, and Lowell was no exception. Members of the Know-Nothings felt it their duty to purge America of foreign, especially Catholic, influence.

One of the loudest voices was that of John Orr, who called himself the Angel Gabriel. British by birth, Orr was convinced the pope was ready to bring his own personal army across the ocean to take over the country. He was known to carry a large horn to announce his visits. He would go into towns and stir up trouble and then march through Catholic neighborhoods. His travels were closely watched as he made his way from town to town, leaving mayhem in his wake. In June 1854, his next stop was Lowell.

Even before his arrival, local papers were attempting to calm Catholics and Protestants alike. Newspaper editorials stated if the Irish didn't want people

believing the stereotypes slandered against them, then they should not give in to Orr's incitements but should instead ignore him. To the Protestants, the warning was to keep quiet. If they opposed the Catholic faith, there was a better way of saying so than by following Orr. There was a lot of talk about freedom of speech and how it should be used correctly and for the common good. The editorials warned Orr that if any trouble was made, he would be held accountable. The year 1854 was when the Know-Nothings were at their strongest, and showing even this veiled support of the Irish revealed that the citizens of Lowell had some tolerance.

The details of Orr's visit vary according to which account you follow. One account in the *Lowell Courier* is entitled "Unnecessary Alarm." It makes light of the fear of the Irish, who were "very unnecessarily alarmed lest their churches may be pulled down, their houses demolished, and their heads broken by anti-Catholic mobs." Early twentieth-century Lowell Irish historian George O'Dwyer wrote this account he gathered while taking oral histories of older citizens. He is referring to Patrick Manice, a leading real estate owner and Catholic advocate. Manice owned a home and barn where the South Common is today and where Orr gathered his minions on his visit: "When the 'Angel Gabriel' was exhorting a crowd on the Common on one of Paddy's fish-barrels, Paddy slyly kicked the fish barrel from under 'Gabriel' and his lecture and himself collapsed. Manice was a quaint character but a staunch Catholic of the Know-nothing period."

The unnecessary alarm mentioned earlier did account for a twenty-four-hour watch that was set in the tower of St. Patrick Church awaiting the mobs. The Sisters of Notre Dame, who operated the school for girls on Adams Streets, had a different point of view. Their journal relates that they had clothes packed up and had removed a board from the convent fence for an early escape if needed. A sister did write a firsthand account of the happenings of this period. In an account called the "Pioneer History," found in the "Annals of the Sisters of Notre Dame, 1852–1958," a sister wrote:

> *Days passed in this state of suspense. The Sisters held themselves ready for all emergencies and listened from hour to hour for the boding toll. Meanwhile faithful hearted friends gathered around them and after their hard-days' labor the factory girls congregated in the parlor carrying stones for want of better weapons. Men came nightly to watch with the Sisters hiding in the cellars and in a stern warning declared that if a finger were laid upon the convent there would be hard blows dealt in their defense.*

Just at dusk one quiet evening the ominous peel sounded forth from the belfry. Fear and consternation were in many hearts but trustful prayers in the little convent. The self-constituted defenders stood with arms uplifted ready to hurl their missiles at the first assailant. Yes the Know-Nothings were approaching the church, but they had not counted sufficiently on Irish loyalty and vim. When just within sight of St. Patrick's they were attacked by some strong-armed Irish men and women—Yes women for these lead the attack.

The 1887 obituary of Julia Castle (Cassell), wife of Henry Castle, recalled the event:

Putting a large rock in an apron, she called upon the neighboring wives, mothers, and sisters to follow her example, and soon full fifty women were massed in front of the convent gate, led by the dauntless Mrs. Castle. There they stood, shoulder to shoulder, right in the teeth of the advancing horde, each one firmly resolved to let the infuriated Know-Nothings trample over her body ere the gates should be forced and the sacrilege consummated.

Leading the military company was a burly policeman, whose sworn duty was to preserve peace and order. He was some thirty yards in advance of the rest, his zeal in the cause having quickened his steps. When he pompously ordered the woman to make off and clear the way, instead of being obeyed as he expected, he found himself in the grasp of a pair of stout Irish arms, and felt himself lifted bodily off the ground. The canal was nearby, but before the approaching mob could come up he was seized by the scruff of the neck and the seat of his trousers, and was flung into the slimy depths. The crowd halted in amazement at the audacity of the thing, and then, by one of those instantaneous impulses which sometimes turn the current of events and shapes history, the mind of the mob was diverted from its infamous purpose. The sight of the half drowned wretch as he floundered and splashed in the reeking water ere he crawled up the banks, changed the yells of rage to shrieks of laughter, and gave men time to take a second thought of what they were contemplating. When old Mrs. Castle, her straggling grey locks unconfined, bade them come on and get treated to more drinks of the same tap, they turned about and slunk home. Had the convent been burned there would have been a bloody retaliation that night, and many who participated would have never seen the light of another day.

THE SMELLING COMMITTEE

If things were not bad enough for the sisters, they were made worse by threats of visits of the Smelling Committees. Part of the Know-Nothing propaganda that the group's members spread was that Catholic convents held torture chambers and secret ceremonies. The sisters' journal, which held a record of events in the convent, relates this account of June 1854 of one of the committee's many visits:

At last on the 15th of June came the dreaded ordeal. Between eleven and twelve in the morning a carriage drew up before the convent and five well-dressed men alighted and sought admission. The Sisters were just sitting down to dinner when the alarm of "Know-Nothing!" was given and according to previous directions a speedy message was sent to the pastor, the Rev. Timothy O'Brien. While the Sisters were parleying with the new comers at the entrance the Rev. Father made his appearance and in his fearless strength seemed an overmatch for the five intruders. "What is your business at the house?" asked the worthy priest. "We wish to inspect the

Notre Dame Academy students at Grotto, circa 1900. *Parish Archives.*

premises," they answered. "You may follow me and see what is to be seen but I warn you not to lay a hand on anything in this holy dwelling." The so-called committee conformed strictly to orders, and they were led through several community rooms. When they reached the dormitory the Rev guide paused and informed them that the privacy of the sleeping apartments of the religious should be respected. To their insisting he stoutly declared that they would not set foot within them, and shortly after they took their leave much to the relief of the community. Soon the peace of the house was restored and the episode was a thing of the past and a theme for conversation for many a day after.

The committee made several visits during which its members smoked cigars and went through drawers. Though the sisters had dedicated themselves to teaching the poorest of the poor in the community, they feared the committee, as can be seen in the words of their journal. In an almost providential way, this Lowell incident brought about the end of the power of the Know-Nothings. It appears that one of the members of the committee brought a female friend along and had her expenses paid by the state. When this news became public, one by one, the Know-Nothings began losing their prestige, and few wanted to be further associated with them.

Part III

RISING

The Irish—We now refer to the great and visible improvement that has taken place in the physical condition, in the intellectual character, and especially in the personal appearance of the Irish population of this city, within ten or fifteen years. Fifteen years ago, scarcely an Irishman or an Irish woman could be found in Lowell who could read or write intelligibly, and the highest vocation which they aspired to, and the highest which they were allowed was that of a "mud digger," "hod carrier," or "porter" on the part of the males: and that of a "sweeper" or "scourer" on the part of the females. In fact, the Irish, then, were glad to do "anything" to save themselves from starvation. They were refused employment in the mills, for their intellectual conditions was [sic] regarded so low as to not afford them mechanical tact sufficient to enable them to "run" the simplest machinery; besides they were so filthy in their personal habits that no decent American could endure near their approach. A tolerable looking Irish girl or woman was scarcely to be seen amongst the whole Irish population. But what a vast change has taken place! A large portion of the present inhabitants of this city would not suffer greatly from a comparison with a class of native Americans, either in respect to their physical condition, their intellectual developments or their personal appearance. How has this improvement been brought about?
—Lowell Trumpet, *April 18, 1857*

Little did the author of the article realize that in a few short years, the Irish would prove their loyalty to their newly adopted land, enter the political structure to elect many of their own background and fill the ranks

From the *Lowell City Directory*, 1876.

of business, education and service-related fields. Following the Civil War, the Irish would become *the* dominant force in the city. The descendants of those first pioneers who walked from Charlestown in 1822, those who followed after the Irish Potato Famine of the 1850s and the subsequent waves that followed them throughout the rest of the later half of the 1800s would lead the city into a new century. But how would the Irish treat others from different lands who followed them?

CALLED TO SERVE

The Civil War would change America forever. It would affect every man, woman and child in some way at some point in its four years of fighting. The war had many layers and would call on people to make decisions on matters of morals, ethics and loyalties. Lowell was no different. As the city was a cotton town, there were some who saw that the closing of the mills would mean no money for rent, firewood or food. Some saw it as a fight for the principle on which this country was founded—freedom. And still others saw it as an opportunity to show patriotism to the land they called home. For the Irish in Lowell, they, too, had to make decisions. The history that has been passed down to us shows an outpouring of patriotism in defense of the Union on the part of the Irish. But surely the thought of providing for those who remained behind must have been a factor, too. The very first list of volunteers to join the call to arms came from Lowell's Irish.

It is recorded in the *History of Middlesex County*

> *that the Catholics of Lowell, a majority of whom were of Irish birth, were fully awake to the demands of the hour, we learn from the following "Call" which appeared in the local papers the very evening on which the first blood was shed in the Union cause: "Adopted citizens, arouse! The cry of war resounds throughout the land! The flag of our country, which*

we have sworn to support and defend, has been assailed! Now is the time to prove our devotion to the beloved Constitution of our country. Therefore, all those who desire to join a militia company will assemble at the hall of the Independent Guards, corner of Lowell and Suffolk Streets, this Friday evening, to affix their signatures to a document for the above purpose."

The call met with a ready response. Sixty-six men that evening and four more the next morning enrolled themselves as defenders of the Union. On Saturday morning, the company was accepted and the charter received.

A little background is needed before speaking of the war years. The formation of military companies was a tradition going back to the colonial era. Originally, they were to protect settlers from Indian attacks but eventually turned into a type of state militia, sort of a national guard. Most towns and cities had at least one; the larger cities had several. Some of these groups were formed fraternally or by those sharing ethnicity. In Lowell, there were several groups, including the Lowell Mechanic's Phalanx, the Watson Light Guard and the Jackson Musketeers. The Musketeers were named after Andrew Jackson. Though Protestant, Jackson's family shared Irish roots, and he became a hero to the Irish in America.

The Jackson Musketeers were formed in Lowell in 1853. Composed mostly of those either born in Ireland or of Irish parentage, the Musketeers were part military and part fraternal. Patrick S. Proctor was named captain of the militia with Peter A. Rogan and Stephen Castles Jr. as first lieutenants. The group would practice marksmanship and military drills and put on competitions with companies from around the state that would end with great parades and festivities. Their armory was located on Lowell Street near Suffolk and later in the Market building (the old police station now on Market Street). Those who saw their headquarters were impressed with their appointments. Special racks were made to hold their "muskets and bayonets," "neatly arranged in file and numbered. Under each number a recess is built, where each uniform is kept free from dust."

While the Irish members of the Musketeers believed they were showing their allegiance to the United States, not all agreed. Even during the 1854 attack on the Notre Dame convent, rumors swept through the city that the Jackson Musketeers were calling on other Irish companies "at seven o'clock that evening" to cut throats of the citizens of Lowell. Of course, there was no such plan, but it shows the growing fears that certain people had against the numbers of Irish that were filling their city.

All of this came to a head when Henry Gardner became the twenty-fourth governor of the commonwealth of Massachusetts. Gardner would become Massachusetts's Know-Nothing governor. In his inaugural address, he announced his intent to "disband all military companies composed of persons of foreign birth." The Musketeers "considered themselves a military company of American citizens, organized precisely like any other military company that had done no act as a company, unbecoming soldiers, good citizens, or gentleman of the nicest honor." They refused to turn in their arms.

Their colonel was Benjamin Butler, who supported them and openly refused to follow the governor's orders. On the night of February 15, 1855, the armory of the Musketeers was broken into, and all arms were removed. This same act occurred all over the state, and the legality was openly questioned. To Lowell's Irish, the message was clear: though they might have been born there, the Irish were still not one of them. Yet, six years later, they would be called to defend the Union.

Heroes

To commemorate the sesquicentennial of the Civil War, a group of volunteers took it upon themselves to get a count of Civil War veterans buried in St. Patrick Cemetery. A partial list made in the 1930s was found that named some of those who served. There was even a note that, at one point, flags were placed on these graves on Memorial (Decoration) Day. But memories are short. The list was put away, and the flags were forgotten. Using that list, today's technology and literally walking every yard of the cemetery, volunteers recorded over 1,200 Civil War veterans' names. That number does not include those who died on the battlefield and were never recovered or those whose families could not afford to transport home the remains of their sons, brothers and fathers to lie with their forbears in the cemetery. Nor does it include those who spent their remaining days at the Civil War Soldiers Home in Togus, Maine, or those who lived through the war and relocated across the growing country. Something else was discovered doing the census in the cemetery: many have no marker at all to acknowledge the service they gave to their country.

Tuesday, April 16, 1861, was described as a "cold and dismal day." The men of the Sixth Massachusetts had gathered at Huntington Hall to board the

train to answer the call of President Lincoln after the bombardment of Fort Sumter. Reverend Blanchard read an invocation before the soldiers boarded the train. There must have been a mix of enthusiasm and anxiety with the soldiers showing bravado before their wives and children. At the departure of the company, a local paper said: "The color-bearer of the Sixth Regiment is Timothy A. Crowley, a private in the Watson Light Guards of this city, a gallant and patriotic soldier, well-known to our citizens. The flag will be safe in his hands and he will defend it with his life."

There were two train depots in Baltimore, one at each end of the city. For the troops to get from one to the other, they had to march through the city. Baltimore was a haven of secessionists who awaited such an event. When the riot broke out, rocks and brick-a-brac were hurled

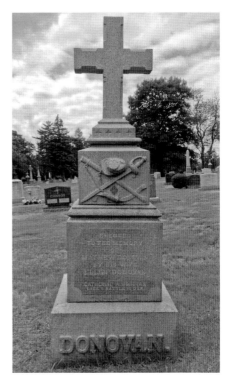

The cemetery marker for Major Mathew Donovan, Sixteenth Massachusetts, Civil War veteran. Note the kepi, sword and scabbard on the headstone. *Author's collection.*

at the troops, and then gunfire broke out. The troops knew only to follow their flag. All depended on Crowley. A Boston paper reported that he was "as noble a fellow as ever wore a uniform of the old Bay State." Waving the flag of the Sixth Massachusetts, he led the troops through the city to a point of safety. The *History of Middlesex County* stated, "Timothy Crowley, the standard-bearer of the regiment, bore himself most gallantly. He might have rolled up his colors and escaped the special notice of the enemy, but he nobly kept them unfurled to the breeze, and to the last stood by the flag which he had sworn to defend."

Upon returning to the city, Crowley formed a company of his own and served in New Orleans under General Benjamin Butler. There he died of fever in October 1862. His remains were brought back to the city of his birth. For his funeral, St. Patrick Church was filled to capacity. The long funeral cortège made its way down Gorham Street, where he was buried in

the same ground as his ancestors. After the rifle volleys finished their echo, the crowds silently returned, awaiting the next news from the war.

Sadly, Captain Crowley's story is just one of hundreds about soldiers who never came home from the war. Next to Captain Crowley's monument in the cemetery is that of David Roche.

The road to Emmitsburg, Maryland, is an iconic pastoral scene. The road begins at Gettysburg center and continues into Maryland. The white-painted fences separate the wheat fields, orchards and farmlands that make up the panorama before you. The low hills that rise and fall paint a scene straight out of an artist's sketchbook. The white-framed farmhouses with their bright red barns stand as reminders to the area's agrarian past. This is also the road where much of the fighting and dying occurred on three days in July 1863. It was the job of the Sixteenth Massachusetts Infantry to defend the Emmitsburg Road.

James and Jane Roche and their six children probably left Ireland about the time of the famine and found employment and housing in Lowell. When their son, David, was old enough, he got a job as an operative in the mills. The family lived on Suffolk Street, and it seems probable that their life resembled that of the many thousands of other Irish living in the Acre. When the call came up for volunteers in 1861, David Roche, like many Irish, signed up and was given the commission of lieutenant. Before the Sixteenth Massachusetts left Lowell, it attended Mass at St. Patrick Church and marched to the trains that would carry its members to war.

The Sixteenth Massachusetts had a full record of encounters in the early years of the war. As 1863 dawned, Roche, who had been promoted to captain, was given a furlough and traveled to Lowell to marry his sweetheart, Margaret Harrington, before returning to the war. The Sixteenth had just finished the battle at Chancellorsville when it was ordered to Gettysburg. By day two of the battle, it was apparent Lee was going to try to take the Emmitsburg Road. It is said that the engaged artilleries of the two forces could be heard all the way to Washington. It wouldn't be until eight days later that Roche's family would be notified that their son was shot in the head during the fighting. Captain Matthew Donovan, another Lowell Irishman who enlisted in the Sixteenth, made sure that his comrade's body was quickly buried under a tree and a marker placed for future identification. Back in Lowell, James Roche, David's father, hired Alonzo Quimby, a local painter, to retrieve his son's body. Bringing the wounded and dead back to their homes became a new business and was advertised in many newspapers. Ads also began appearing in the *Lowell Courier* for women's black woolen shawls.

The ads noted how the capes were in great demand and supplies were being replenished as quickly as possible. Captain Roche's young widow might have taken advantage of the sale.

Mr. Quimby's mission was successfully accomplished, and a full military funeral was carried out at St. Patrick Church. "The services were very appropriate and interesting," reported the *Lowell Courier*. The procession was lengthy with several military companies represented, as well as city officials. I would be remiss not to state that the *Courier* was filled with such sad stories on a daily basis recounting the deeds "of the brave soldiers who sleep their last sleep." Such accounts went on for the entirety of the war.

Not all of the war's casualties were able to be brought home. Francis Cassidy was not the only Lowellian to die at Antietam in September 1862. Few facts surround his brief life, and his simple marble marker at the National Cemetery is all that is left to tell his story.

Maybe it was the lure of the glories of the battlefield that drew him to join the Nineteenth Massachusetts Infantry in August 1861. There were other Lowell boys signing up that day; perhaps that was the catalyst, or maybe it was the lack of work in the city and the need to help the family earn enough to feed themselves. Maybe it was his way of showing his patriotism to his new homeland.

Within a few months, the Nineteenth Massachusetts found itself in Virginia, part of the Peninsula Campaign. Conditions could not have been worse. The extreme heat, unsanitary conditions, diseases from wading through swamp water and lack of food took their toll. Private Cassidy was marked "missing." Eyewitness accounts state that many soldiers, collapsed with dysentery and extreme fatigue, lay along the trails. Some soldiers resorted to eating raw flour that was finally rationed to them, hunger overcoming common sense. What happened to Private Cassidy is not noted, but he did return to his unit before the march to Antietam Creek. He may have thought himself fortunate to have survived the Peninsula Campaign, but his final destiny awaited him.

At 2:00 a.m. on Wednesday, September 17, 1862, Private Cassidy awakened to the sound of reveille. The Confederates were on the move. By dawn, the sound of gunfire had drawn close. The men of the Nineteenth became anxious. Their captain had them go through the manual of arms to relieve the building tension. They were ordered to form three lines. Inept leadership then ordered the Nineteenth to march forward through the cornfields. The long single lines made perfect targets for the Rebel forces as they cleared the fields. The men of the Nineteenth did not stand a chance.

The bodies piled up on top of one another. Those who did make it through found they were attacked on their flank. Their order was to charge, which added more numbers to the slaughter. Less than 50 percent of the Nineteenth survived the day, and these cornfields remain the site of the greatest loss of American lives in a single day. It is most probable that this is where Private Francis Cassidy met his end.

The day after the battle, horse-drawn carriages brought photographers to the battlefield. This new technology documented what Americans had only read about previously. Soldiers bent bayonets into hooks to drag bodies to shallow graves. Private Cassidy was fortunate that someone did so for him and marked a rough-hewn board with his name and regiment. Weeks, months and even years later, many visitors reported limbs and skulls from unburied dead poking out of the ground. Local papers often recorded when bodies arrived and when services would be held. But there was no such privilege for Private Cassidy. More than likely, Private Cassidy's family could not afford to have his remains transferred back to Lowell. Several months later, his remains were reinterred in the National Cemetery, just a mile from where he fell.

There is a sad beauty to this cemetery. Thousands of marble headstones with simple inscriptions of names and regiments line up like soldiers standing at attention. The white markers on a field of green give a sense of peace, countering the tragedy of young lives lost.

Among the stones that were counted in the recent Civil War census was a rather curious one. It reads, "John H.E. Quinn, 75 USCT," USCT standing for United States Colored Troops. What was the son of Irish immigrants doing serving with the USCT? Many Irish saw the opportunity for advancement by serving in an all-black regiment, such as the "Corps d'Afrique." Even though one reason for the war was the end of slavery, men of color, even free men of color, were barred from serving with white troops. When "colored" troops were finally formed, only whites could serve as officers, and many refused commissions with the USCT. Whether John joined for this reason or as a matter of ethics, there is no mention. John Quinn was commissioned major of the Corps d'Afrique. His life after the war was just as interesting, as he was part of the Fenian invasion into Canada in 1866. He was captured and sent to prison in England. His death in 1887 was attributed to the long-term effects of malaria contracted during the war.

TO HEAL THE SICK: ST. JOHN'S HOSPITAL

As if Sister Emerentiana of the Daughters of Charity, who operated the St. Peter's Orphan Asylum, wasn't busy enough seeing to the needs of her growing flock, now she had a request from Father John O'Brien of St. Patrick Parish. For years, Father John had been operating a little hospital for the poor near the church. The conditions he found for the Irish upon arriving in 1848 caused him to open an infirmary in a small house on Adams Street. This was overseen by the already busy Sisters of Notre Dame, who ran St. Patrick School, and ladies from the church's sodality. Necessity caused them to move to a house on Lowell (Market) Street as more Irish entered the city.

Lowell was not without medical care prior to Father John's attempts. The Lowell Corporation Hospital, founded in 1840, served all citizens but especially those who worked in the mills of the city. Those who did not work in the mills had a small fee to pay. Whether it was financial or some other reasons, records show few Irish took advantage of the Corporation Hospital.

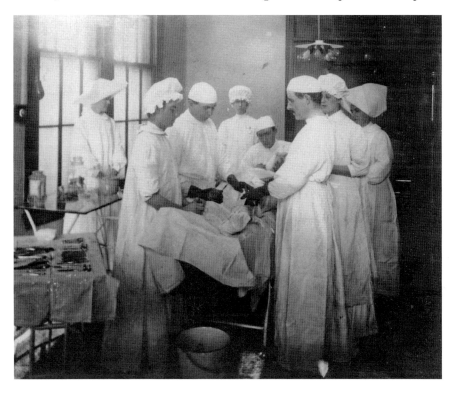

St. John's Hospital operating room, 1920s. Note the Daughter of Charity in a traditional habit in the background. *Lowell General Hospital, Saints Campus.*

What Father John proposed to Sister Emerentiana was to open a small hospital for the needs of the Catholics of Lowell. The Sisters of Notre Dame were really a teaching order, and as the number of students increased, their duties increased, requiring them to focus on their mission. Sister Emerentiana brought the proposal to Archbishop Williams, who approved the idea.

The first home of the hospital was the "Yellow House," the property of the Nesmith family. Money had to be raised, and a series of fairs were held in Huntington Hall beginning in November 1866. It seemed every Catholic organization and every city official showed up for the event. Each group had a table offering all kinds of goods and raffles. Concerts were held, one even with the famous Patrick Gilmore band.

When the Sisters of Charity of St. Vincent de Paul (known for their distinctive religious habit) took over the Yellow House, they found thirty families living in it. They had to be vacated, though no one mentions to where they were sent. The first superior was Sister Rose, and her little group of sisters led the renovations of the building, financed by yet another series of fairs. Owen Meehan gave the sisters enough credit in his store to furnish the entire building, paying as they could. There were separate floors for men, women and the sisters.

The first patients were Nellie Collins, Hannah Dailey, Celia Brady, Bridget Mullen, Isabelle O'Brien, Bridget Gormley, Mary Reagan and Bridget Sullivan. They were the last patients of the little hospital on Lowell Street and were transferred to St. John's. The numbers for the new hospital grew as soon as the doors opened. The original medical staff consisted of six doctors, who rotated rounds and consultations. Among them was Dr. F.C. Plunkett, a native of County Mayo, Ireland. When the doctors weren't present, the hospital was left in the hands of eleven sisters, who did everything from medical care and mixing their own prescriptions to laundry. Almost immediately, Sister Emerentiana started signing loans for new buildings and new equipment. Within a short time, the hospital became a model of the best medical practices and hygiene.

A souvenir booklet of the twenty-fifth anniversary of the hospital recounts its unbelievable charitable work. A number of articles in the *Lowell Courier* throughout the period note the cooperation between the Irish Catholic and the French Catholic communities, which began immigrating to Lowell about the time of the Civil War. For so much to be written about this, conditions must have existed to cause them to unite. The writer stated he hoped this would be the beginning of many other such endeavors of cooperation between the two groups.

Faith of Our Fathers

Wherever the Irish settled across the country, they brought their faith and their support systems with them. As immigrant numbers swelled due to Ireland's famine, the newcomers seemed to be caught between two worlds. While they wanted to maintain the customs of their forefathers, they also wanted to become a part of their adopted homeland. Leadership was needed, and names like Hugh Cummiskey, Charles Short, Stephen Castles, Samuel Murray and, especially, Father James T. McDermott are mentioned time and time again as those who would be sought by people looking for employment, charitable needs or spiritual advice. They would be the link between the old world and the new. But undoubtedly, the strongest influence and the most visible—and possibly the most grating to some of Lowell's Yankee population—was their church. A city that had been built on the ideals of the Protestant work ethic was slowly turning into a place where the number of Catholic churches would be rivaling that of Protestant ones.

As the Irish spread throughout the city, they created neighborhoods, and each neighborhood formed its own parish. While they shared a common faith, there was also strong identity to one's parish, reminiscent of their pioneer forebears who settled in the Paddy Camps based on their county identity back in Ireland.

St. Patrick Church

From its humble wooden-framed beginnings in 1831, St. Patrick's grew to one of the most impressive buildings in the city with the erection of the thirteenth-century stone Gothic structure replacing the old. Under the direction of Father Timothy and Father John O'Brien, famed architect Patrick Keely created the church, opened in 1854. As impressive a structure as the church is, there was one more level to be reached. Father Michael O'Brien, nephew to the other priests, was named pastor upon Father John's death. Father Michael wished to add his own lasting mark on the parish and the Irish presence in Lowell; he wished to have St. Patrick's consecrated, an act of leveling the church to a higher realm of sacredness reserved for only a few churches.

First, the debt on the church had to be fully paid. Many parishioners pledged large amounts of their wages to see that this would be accomplished,

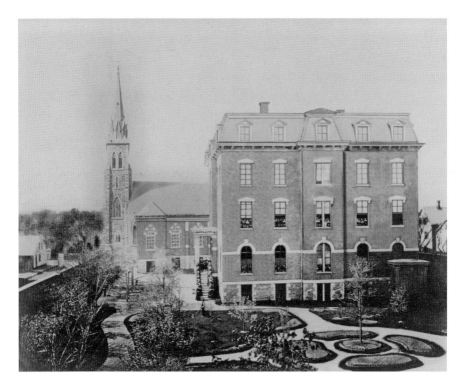

St. Patrick Church and Notre Dame Academy, 1890s. *Archives of St. Patrick Parish.*

though living conditions in the Acre were the worst in the city. The Lowell newspapers carried news of the approaching date of the dedication, for which the admission was seventy-five cents. On September 7, 1879, Bishop Williams spread sand on the floor of the church and wrote the letters of the Greek alphabet as a sign of claiming the church. He then walked around the church three times sprinkling water on its walls. Relics of Saint Patrick and Saint Phillip were placed on the altar. St. Patrick's was the crowning glory of the Irish presence in Lowell.

The night of January 12, 1904, would never be forgotten by the people of the Acre. A Sister of Notre Dame looked out her convent window and saw a glow of orange in the night sky. The church was ablaze. Before their eyes, the crowds that had gathered saw the cross on the steeple sway and fall into the church. Firemen used their hoses to break the stained glass to get the water inside. Father William O'Brien, who had replaced his cousin Michael O'Brien when he died, unashamedly stood before the church and cried.

Two years later, Father William entered the new church that had been rebuilt by the parishioners' efforts. The walls of the church had withstood the blaze. Clerestory windows were added to the height of the church. Father William had them added to illuminate the murals he had installed along the vaulted ceiling. The murals recount the story of the miracles of Jesus. German muralist Gustav Kinkelin designed the artwork and personally saw them installed. The Fifteen Mysteries of the Rosary was chosen as the theme for the new stained-glass windows. By the organ, said to be the finest in the city, was the tallest window—that of Saint Patrick preaching to the chieftains at Tara. A new altar was designed and sculpted by Joseph Sibel, replacing the damaged one that was moved downstairs (and is still there today). A big change was the moving of the altars of the Sacred Heart and St. Dominic—installed in the 1890s to celebrate the anniversary of Father Michael O'Brien—from the transepts to the front on either side of the main altar. This covered up two former window sites, but the effect was most pleasing.

The church was made to be almost identical to the one from before the fire. A sacristy was added to the side so the priest no longer had to vest in the cold cellar. Electric bells were added behind the altar so they could be rung automatically at the lifting of the chalice and host. Rubberized flooring was added to quiet the shuffle of shoes. The capitals of the columns were filled with tiny figures of squirrels, ducks and birds. Over one thousand gas and electric lights illuminated the interior.

At the dedication, Cardinal O'Connell ended his sermon with a reminder that the church was not only the building but also the people of God.

St. Patrick School and Notre Dame Academy

Being men of vision, the O'Briens knew that the way for the Irish to improve their situation was through education. While the Sisters of Notre Dame opened a school for the girls of the Acre in 1852, their mission did not end there. Their superior, Mother Desiree, saw the needs of the younger children in the neighborhood whose parents worked while they remained unsupervised. She opened a nursery school for them. In 1854, she opened a boarding school that would help fund her other projects. The journals of the sisters recount how Desiree would never deny food to any of the out-of-work laborers who would come to the convent door. Mother Desiree also had chickens and cows brought onto the convent grounds to

Notre Dame Academy graduating class, early 1900s. *Archives of St. Patrick Parish.*

help feed the sisters and those who asked for food. She built a convent and a wall to enclose the property. Later, the sisters added a high school for the girls not attending the academy. The boarding school that would become Notre Dame Academy operated in the Acre until growth necessitated its move to Tyngsboro in the 1920s.

St. Patrick Boys' School

Educating the Irish boys was another matter. Michael O'Brien had a plan; he always had a plan. He was from a family of planners. Like his uncles before him, Fathers John and Timothy O'Brien, he was a man of vision and took his role of shepherd of the flock seriously. Father Michael, as his congregation called him, saw the fruits of his predecessors' labors. While the girls were given the chance of being educated, the boys were a different problem. Choices for the boys of the Acre were limited. They could attend

the public school, roam the streets or get themselves into the mills. But that little worm began crawling inside Father Michael's head, and it wouldn't stop until the time was right.

Brother Alexius sat at his desk in Baltimore. He couldn't take much more. The letters were coming one after another. Not only was Father Michael O'Brien writing to the Xaverian Brothers, but Brother Alexius was also receiving letters from others on Father Michael's behalf to bring the brothers to Lowell. They were all urging the brothers to open a school for boys in Lowell. Brother Alexius finally gave in. He agreed to send four brothers to open a school to begin in September 1882.

The old St. Mary Church on Suffolk Street had been empty for years. Following McDermott's death in 1862, it remained vacant, ready to be part of Father Michael's plan. Yes, it would make a fine schoolhouse. What used to be the basement of the church now had a proper reception hall, dining hall, kitchen (both of these "being models of neatness") and water closets. The second floor had the students' classrooms. Two students sat at each desk sharing one ink bottle. The third floor had the brothers' dormitory, study and chapel. The curriculum would be based on commercial studies, including bookkeeping, algebra and geometry. The entire course of studies

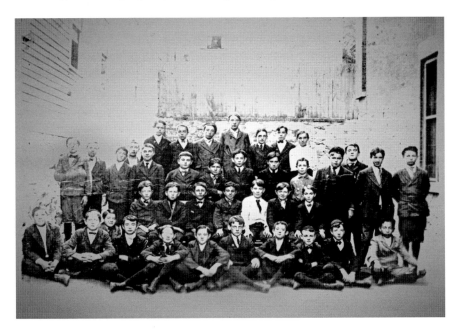

Boys' School, St. Patrick Parish, date unknown. *Sheehy family collection.*

would take perhaps seven years. The intent was to have grammar and high school students.

Opening day in September 1882 began with the Mass of the Holy Ghost. The principal, Brother Joseph, and his three companions stood ready as the boys lined up outside the school—all 348 of them. He immediately telegraphed to Baltimore to send help. This was a most auspicious beginning, and all went as expected for a number of years. In accounts written by the brothers, they described the Irish boys as being "the worst of the worst." A suspicious fire closed the school for a number of years. With fewer vocations, it became more difficult to operate the school.

On October 19, 1939, St. Patrick Boys' School on Suffolk Street was sold by the Archdiocese of Boston to the Lowell Housing Authority. The land was wanted in order to enlarge the scope of the North Common Village housing project. The brothers remained for a few more years until the boys' and girls' schools were merged under the direction of the Sisters of Notre Dame.

St. Patrick's Home

Who knows how many tens of thousands left the homes of their mothers and fathers and made their way to the mill cities of New England? During Lowell's Golden Age, company housing was provided for the single women. Their boardinghouse had strict regulations and was overseen by a matron who was there to ensure that the corporation's reputation remained intact. Lowell was not about to become another Manchester, England.

As the decades passed and more mill towns began sprouting up, the utopian ideal of the perfect mill town began to fade away. That did not stop the number of women who made their way from foreign lands and small farms seeking mill jobs in the big cities. But what would happen to them without the boardinghouses and matrons? The newspapers were filled with horror stories of young girls coming to the city and being confronted with the evils of city life.

The solution was the Working Girls Home. In the later half of the nineteenth century, religious institutions, social organizations and some individual philanthropists began finding homes where girls new to the city could find housing and where a clean bed, good meals and a safe environment would help with the transition. Lowell was no exception. As the corporation boardinghouses closed one after another, the need for such a home became evident.

In 1896, the priests of the St. Patrick Parish took it upon themselves to purchase the property next to the church on Cross Street. It was the old Moran's Yard, and everyone in the neighborhood knew what went on there at all hours of the night. The architect was none other than the famed Patrick Keely, the same architect who had worked on the church. The four-story brick structure would have granite windowsills and doorways. The fifty rooms would allow light to fill the building and make it an inviting home to those in need.

The financial undertaking was massive. The ladies of the parish sponsored a bazaar to help defray the cost. The event went on nightly for two weeks and was held at the American House. The grand prize was a diamond stick pin. Other awards included a barrel of flour, a lemonade set, a print of St. Cecelia "and a handsome writing desk." Fifteen young ladies were the first guests. It was decided it would be open to women of all faiths and would include those too old to care for themselves. Even three years later, the parish was still paying off the debt. That is when Father Michael O'Brien gave a personal purse of $40,000 toward the mortgage. This was money given to him in honor of his ordination anniversary. For many years, the Fathers O'Brien would routinely make trips back to Ireland and bring back friends and family to find jobs in Lowell, some of whom would make the Working Girls Home their first home.

The Franciscan Sisters of Allegany were put in charge of the home. They oversaw the physical and spiritual needs of the girls and took gentle care of the aged and infirm. The girls paid a small stipend of what their take-home pay would be. Those who could not afford it paid nothing. As the years passed, fewer and fewer young women saw the need for such a facility. Eventually, the home became "the old ladies home." By 1967, the building was showing its age. Newer facilities were opening. The government was providing better resources, and there were fewer vocations available to those who would give their lives serving the aged. The building closed and remained empty until it was torn down around 1970.

ST. PETER'S CHURCH

Much like St. Patrick's, the church serving the Irish of Gorham Street was overflowing within a few years of its being built. Even when a second pastor, Father Crudden, made improvements to the church, it did not have the

St. Peter's Church, interior, about 1899. *Guy Lefebvre collection.*

capacity for all its parishioners. It was clear a larger church was needed. At the same time, the government was looking for a place to build a new post office. Old St. Peter's was the perfect placement. Gorham Street Hill was chosen as the ideal location. The purchase of the land was long and exhaustive since three parcels had to be bought for the size and number of

buildings that were envisioned. During the demolition of the old church, the cornerstone was located and, in it, an old tin box containing a number of items. There were copies of 1841 newspapers along with "an Irish sixpence, an Irish temperance, a Father Mathew and an Immaculate Conception medal along with several pamphlets." Old-timers stood on the corner watching the church they loved being torn down. A flock of doves flew out of the steeple before it was demolished.

A rectory was built before the church was begun. The new church was designed by P.C. Keely. Gothic style with two towers built with Acton granite, it was an immense structure measuring 196 feet by 91 feet. The crowds for the laying of the cornerstone filled the area of what would be the downstairs church and crossed over Gorham Street. Archbishop Williams led the services. When the church was completed in 1900, one would climb the massive granite steps and enter the large nave to find five marble altars illuminated by massive stained-glass windows. Its presence could be seen from many parts of the city and was the center of the Chapel Street Irish community. The church was closed in the 1980s and demolished years later.

ST. PETER'S ORPHANAGE AND SCHOOL

Father Crudden asked the Daughters of Charity to come to Lowell to take care of the needs of his growing flock. At first, the sisters made home visitations to the sick, but eventually, the priest and nuns saw a greater need. With living conditions for the poor Irish across the city as they were, the

St. Peter's Orphan Asylum, undated. *From* One Hundred Years of Progress.

St. Peter's School, graduating class, 1928, *Author's collection.*

number of deaths from diseases like typhus and cholera is not surprising. There were children who were left parentless, and there were children who were left alone for extended periods due to parents working twelve to fourteen hours a day. The solution was to open an orphanage for young girls to be called St. Peter's Orphan Asylum and later St. Peter's Orphanage. Father Crudden bought a plot of land on the corner of Appleton and Elliot Streets. The Daughters of Charity opened the orphanage in 1865 and turned it over to the Sisters of Charity of Halifax when the daughters took on a new mission. The orphanage had another home on Stevens Street and finally closed in 1956. The Sisters of Charity also operated St. Peter's School across from the church beginning in 1913 until its closing.

St. Michael's

For many Catholics, parish affiliation took precedence over merely being Catholic, but that was not always the case. One Sunday in November 1883, the aging Father Michael O'Brien of St. Patrick Church climbed the stairs

to the pulpit to begin his sermon. What he said surprised the congregation. Bishop Williams had mandated a new idea, dividing cities into geographic sections where anyone living within that area must attend that church. For Lowell, that meant the Irish of Centraville would no longer have to make the trek across the Merrimack River to attend St. Peter's or St. Patrick's but could have a church of their own. The new parish would have a large geographic area covering Centraville, parts of Dracut and Collinsville.

Father Michael named his cousin Father William O'Brien to be the first pastor. Until the church was finished, the firehouse on Fourth Street was used as a church on weekends. April 27, 1884, was a day that Lowell would long remember. The Immaculate Conception Temperance Society, along with the Lowell Cornet band, began marching through the city. They began at St. Patrick's, where they were joined by five more societies, and as they made their way to the site on Sixth Street, city officials and clergymen joined in the procession for the laying of the cornerstone. The design of the church was another masterpiece of famed architect Patrick Keely, who had previously worked with the O'Briens of St. Patrick's. Keely built his structure on top of the basement church in an effort to have it completed as soon as possible. The altar was donated by Mr. Timothy O'Brien, brother of Father Michael.

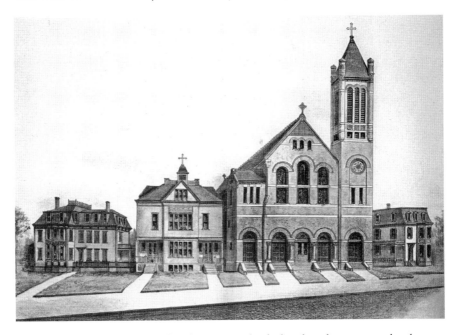

Plan for St. Michael Parish showing the rectory, school, church and convent, undated. *Archives of St. Michael Parish.*

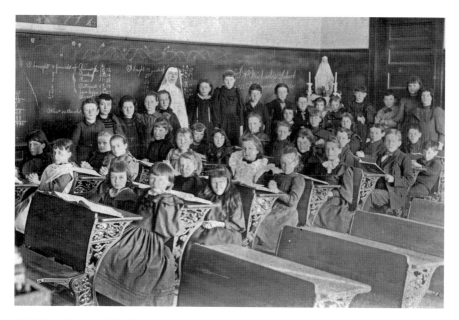

St. Michael School, 1896. Note the Dominican Sister in the image. *Archives of St. Michael Parish.*

Finally, in June 1900, Father Williams, who had been named Archbishop Williams by this time, claimed the church under the protection of Michael the Archangel. He walked around the church sprinkling holy water on the walls of the church as the choir sang the Litany of the Saints. The growth of the new parish required Father William to seek the help of four curates over the coming years. Religious and social societies were formed for men and women, and junior societies were formed for boys and girls. All focused on building up the new parish while instilling values of the faith. The Catholics of Centraville now had a church to call their own. As Brian Mitchell, in his history of the church, points out, many felt that Father William's legacy was the building of the church property while his lasting gift was to build a community.

Even before the church was completed, Father William built a parochial residence and immediately set to work to make space for a school and convent. The school was part of a mandate by Bishop Williams to keep Catholic youth educated not only in the three Rs but in religion as well. Father O'Brien also used this as a way of building his new community, mostly composed of recent Irish immigrants and later-generation Irish as well. The "white robed" Sisters of St. Dominic from Kentucky were brought in to open

a school. The original two-and-a-half-story wooden structure had classrooms on the first floor for primary students, the second for upper students and the third floor for exhibition and assembly space. Three hundred girls opened the school in 1889 with four sisters. The following year, boys were allowed to enter. The majority of students were of Irish background. Parents felt it their duty to have their children instructed in the faith, and the school grew quickly. If that was not enough work for the sisters, they also taught Sunday school. By the turn of the century, the school needed nineteen sisters to man its classrooms.

CHURCH OF THE IMMACULATE CONCEPTION

The life of the sisters who staffed St. John's Hospital was arduous enough, but to fulfill their duty to attend daily Mass, the sisters had to walk from the hospital to St. Peter's Church, a daily three-mile walk. A small chapel was already located in the newfound hospital, but a priest was needed to say Mass. Bishop Williams and Father John O'Brien had convinced the superior of the Oblates of Mary Immaculate (OMI) to come to Lowell to talk about getting a priest for the growing number of French Canadians. While on the visit, the group went to the chapel at St. John's. The bishop remarked that it would be advantageous to have a priest regularly visit the chapel to say Mass for the growing numbers in Belvidere. The superior found himself in a position where he was now being asked to provide for two situations. The bishop told the superior that, once it was established, he would turn it into an Irish parish. And so in April 1868, Father Andrew Garin and Father L. Lagier arrived in Lowell.

This was the beginning of Immaculate Conception Parish. Two more oblates, Fathers McGrath and Mangin, were sent for and gave a retreat. Over six thousand people came from all over the city to hear the sermons of the priests. The numbers were so large that people had to be turned away. It was obvious that Belvidere was ready for a church of its own, but building it wouldn't be easy. The location chosen would be where the chapel stood, but the land needed to build on was covered by numerous small buildings and residences. One by one, lots were purchased, but a certain Mr. Leavitt refused to sell. Mr. Leavitt finally acquiesced, but through a strange agreement, the priests lived in one half of the Leavitt house while their residence was being built, and the Leavitt family lived in the other half. Each half was separated

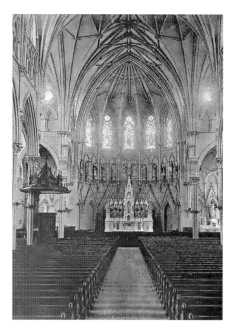

Immaculate Conception Church, interior, undated. *From* One Hundred Years of Progress.

by a thin partition. The fathers wrote that when they would be chanting their prayers, Mrs. Leavitt would be loudly playing her piano.

The cornerstone was laid on the last day of December 1870. An earlier date for the ceremony had to be postponed due to a smallpox epidemic. Though the temperature reached the negative-fifteen-degree mark, still two thousand people came to witness the event. Like for the other Catholic churches of Lowell, Patrick Keely was called in to be the architect. He had been invited the previous year and personally chose the spot on which to build. He was doing this while also building Boston's Holy Cross Cathedral. The finest artists, sculptors and glass makers were hired to build this house of God. Gothic in design, cruciform in shape, made of Dracut granite and paid for through the work of immigrants, Immaculate Conception would give those who labored so hard in Lowell's mills a little glimpse of heaven.

An imposing ceremony took place in 1878, when the relics of Saint Veracunda, an early martyr, were carried in procession and laid onto the altar stone of the church. Thousands came to witness the event and mark the milestone in the church's progress. During the homily, Reverend Haggerty spoke of the unwavering faith of the saint and compared it to that of the Irish people and those who built the Immaculate.

IMMACULATE CONCEPTION SCHOOL

Like its sister parishes of St. Patrick's and St. Peter's, Immaculate Conception went to work right away to erect a school for the education of the children of the parish. Land was purchased on Merrimac Street with future plans to

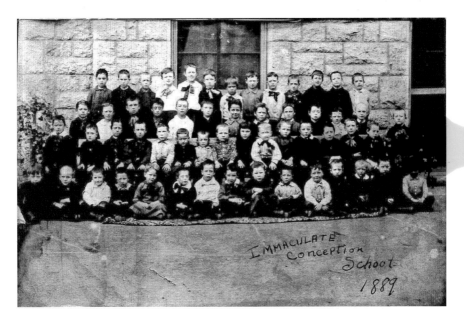

Immaculate Conception School, 1889. *Archives of the Gray Nuns of the Sacred Heart.*

build a high school. The four-story building was made of brick and granite and cost $20,000. Over the pediment was a marble slab with the inscription "Parochial School, OMI of the Church of the Immaculate Conception." Eight Grey Nuns of the Cross (two French speaking and six English speaking) opened the school on Monday, September 6, 1880, with seven hundred students in attendance. The Grey Nuns, though founded as a French order, had done work with Irish immigrants in Montreal and Ottawa, and the number of vocations among them increased. On the first day of school, the children attended the Mass of the Holy Ghost. In the 1920s, the Grey Nuns of the Sacred Heart took over the school.

SACRED HEART CHURCH

The last of the Irish parishes to be established in Lowell was Sacred Heart Church. Reverend William Joyce OMI, a native of County Waterford, Ireland, was chosen to be the first pastor and given charge of raising funds. After attending seminary in Ireland, he studied further in France. He was transferred to the wild territory of Manitoba, Canada, where he preached

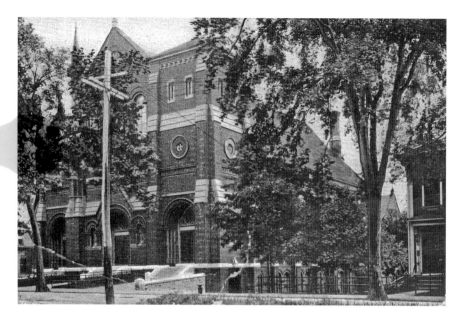

Sacred Heart Church (postcard), undated. *Author's collection.*

to the Indians and was then given his assignment in Lowell. He was twenty-eight years old.

Father Joyce called the male members of the Bleachery and Ayers City sections of Lowell to a meeting in April 1884 to organize a way to raise funds. Some of the early organizers were Maurice Kennedy, Patrick Buckmaster and Thomas and Edward Grady. No names of women were mentioned. As was done for organizing previous parishes, it was decided that a series of fairs would be held to raise the estimated $75,000 to complete the church.

Land was purchased on Moore Street, and work was begun immediately. By August, the basement of the church was ready for services. The church was to be made of brick and built in the Florentine style. Since the area around Moore Street was more sparsely settled than other sections of the city, the building was not as large as its counterparts.

Even in the first years of the parish, parishioners requested that the annual St. Patrick's Day parade pass by the church as it did for the three other Irish parishes of the city. The motion was defeated. But the parish maintained strong roots with its annual "Irish Nights" and was well known for its lectures on Irish culture and entertainments.

SACRED HEART SCHOOL

Across the street from the church, another lot was purchased for the erection of a school and convent. The first classes were held in September 1892 under the direction of the Sisters of St. Mary of Namur, another order dedicated to teaching immigrant children. When the school opened, to show the community's patriotism, an eighty-foot flagpole was erected with a magnificent flag. The pole was surmounted with a ball and cross. Inside the ball were the names of all the first students of the school.

Not enough can be said of the faith and devotion of the women and men who built these places of worship. Reading the histories of each, you can sense the pride and effort it took to achieve such herculean acts. These were the children of immigrants, most millworkers earning little pay, many living in conditions we cannot imagine. But through the work of their hands and the sweat of their brows, they built places where they could maintain the faith for which they were persecuted back home and give their children an education and advantages they were denied. It may do us well to remember we live in their shadows.

Sacred Heart School, class of 1928. *Archives of the Sisters of St. Mary of Namur.*

MEN OF DEEDS AND BUSINESS

The Rubber Heel King: Humphrey O'Sullivan

Some say it was his years spent in the printing business, standing for hours setting type, that gave him the notion to revolutionize shoe materials. Who knew that tired feet would soon make Humphrey O'Sullivan known worldwide as the rubber heel king.

O'Sullivan was born in Skibbereen, County Cork, in 1853. He spent a brief period as a teacher and then entered the printing trade. He came to New York in 1874 and took another position as a printer there before joining his brother in Lowell, where his brother owned a small shoe business. He finally became a partner with his brother James, and that's when fortune struck. The small shoe company not only sold shoes but made them as well. That's when he came up with the idea of putting a rubber heel on shoes in place of the wooden or cork heels used. The two brothers pooled their money and put it all into their new venture. They patented their invention in 1899, and it paid off—it paid off well.

With his savvy use of advertising, the brand of O'Sullivan Rubber Heels was known around the world. While the man amassed a fortune from his start of $1,800, he never forgot his roots. He lived modestly in his home on Butterfield Street, never moving into newer, fancier neighborhoods of the city. An outspoken advocate of Irish independence, he maintained active

Humphrey O'Sullivan, advertisement. *Author's collection.*

membership in most Irish organizations in the city. A Democrat to the core, he was a leader of his party at rallies.

Upon his death, having no children, he left most of his estate, worth millions, to the church. At his passing in 1931, Mayor Curley of Boston wrote, "It would be difficult to name any man of Irish birth in the history of Massachusetts who ever rose to greater heights in the business world solely through his own personal effort and who more greatly merited the success which was won by unremitting toil."

The Rum Riots and Patrick Dempsey

His obituary read like the cause for canonization of a saint. He was a man of few words, but when he spoke, they had worth. His name appears as a regular contributor to a number of causes, especially to St. John's Hospital, where he contributed preserves, sugar and a child's bathtub. He was one of the founding members who donated heavily to the hospital's opening. His name appeared frequently for sending floral tributes to funerals of friends, neighbors and employees. He was so well known to his fellow Irish that he was asked to be a pallbearer at Father John O'Brien's funeral. It was said that he was the first of Lowell's Irish immigrants to have earned considerable wealth.

Patrick Dempsey's financial status enabled him to buy considerable real estate, centering on the Acre. He bought an estate on Salem Street, where he made his home for his two wives and a dozen children. Though he could have moved into any of the newer neighborhoods, he chose to remain in the Acre. The property attached to his home was called Dempsey's Place and was a heavily crowded series of tenements typically rented to other Irish. He also bought property in Salem, Massachusetts, where he had a summer home, and his family often made trips across the country. His son, however, would move into a great home on Andover Street following his father's death.

At one point, he was sued by a neighbor for erecting a high stockade fence that she argued caused an unhealthy lack of light resulting in sickness and even a death in her home. And then there was the case where Mr. Dempsey sued the Congregational Church on Merrimack Street for water damage from the church's gutters that flooded Dempsey's liquor business on Lowell (Market) Street. He made it a point to stay out of politics but could be quite outspoken if there was a possibility of his property being re-zoned or of tax statuses being altered.

Born in County Wicklow, Patrick Dempsey came to America and began work in a print and dye factory. He moved from place to place until landing in Lowell. He rented a basement on Lowell Street, where he brewed root beer. He was so successful that he branched out into beer and other spirits. Within a few years, he became the leading saloon owner not only in Lowell but also in the entire state. He turned brewing into a big business, opening shops and bars across the city and dealing spirits across the state.

The nineteenth century was a period of great change. The temperance movement had begun in the early part of the century and made advancements throughout the decades. Across the country, laws were being passed with restrictions on who could brew alcohol, where it could be brewed and how much could be brewed. Massachusetts was no exception. The state sent sheriffs out to seize barrels of the stuff during a particularly strict period of prohibition in the 1870s. When the sheriffs came to Lowell, they visited Dempsey's establishment first, as it was the largest. A *New York Times* edition from August 1871 carried the story. As soon as word got out that they were at Dempsey's, a crowd from "the lower strata of the population" gathered. "The roughs collected, ready for a row or fight." The crowds began stoning the officers. One of the ruffians used a hoe to strike an officer. The officer's gun fired during the mêlée, hitting one of the crowd. The man who struck the officer, Pender, was arrested and held for bail, but his case was quickly moved since his family was known to have smallpox. The next day, the crowd returned but was informed of undercover constables in the crowd who were ready to stop any trouble before it erupted. The establishments that were visited read like a list of Lowell's Irish who's who. There was Lynch, Cummiskey and Collins. It went on. The constables came back for yet a third day when the crowds started up again. This time, the constables came back in full force. They were supported by women and girls waving handkerchiefs and shouting, "Huzza," cheering on the police. Over the three days, hundreds of barrels of alcohol were confiscated and placed under guard until they could be shipped to Boston. There were fears that the crowds might attempt to remove the spirits.

Things must have changed quickly. Very shortly, Mr. Dempsey was back in business, and his advertisements were back in the papers. His son took over the business and even moved it to Boston, where the Dempsey name was exported across the country. His son was rumored to have tried influencing Lowell's politicians by swaying elections. Dempsey died in 1902. The church where he worshipped for over fifty years was filled to near capacity. He was laid to rest in the Catholic Burial Ground, and the era of the old Irish immigrant making good came to an end.

His Eminence: William Cardinal O'Connell

My teachers at that time were of the strictest puritanical mould, with the coldest idea of duty as they saw it, without the slightest understanding of a child's mind and heart, and with a suspicion and distrust of everything Catholic. We lived actually in an atmosphere of fear. We sensed the bitter antipathy, scarcely concealed, which nearly all these good women in charge of the schools felt toward those of us who had Catholic faith and Irish names. For any slight pretext we were severely punished. We were made to feel the slur against our faith and race, which hurt us to our very hearts' core. As all the teachers were of this same stamp, it was little wonder that from my fifth to my twelfth year school life meant nothing to me but a dreary drive with a feeling of terror, lest, for any reason or no reason, the teacher might vent her ill feeling upon our defenseless persons.

Those words were written by William Cardinal O'Connell, Lowell born and America's first native-born prelate of the Catholic Church, in his autobiography, *Recollections of Seventy Years.* Since his death, much has been written about the cardinal's time in office. His ego appears to have been bigger than the man himself. He was known to drink fine liquors and smoke expensive cigars. He chummed with the Boston elite. His influence went far beyond ecclesial matters. He was friends with the Kennedys and influenced politicians with his edicts.

He continued his life's story with several events from his youth in which he saw his fellow Irish citizens being mocked or ridiculed for their faith and culture. The son of immigrants from County Cavan, he lived with his mother and siblings in the Chapel Hill area of the city and attended the Edson School. He recalled walking over to the convent of the Sisters of Notre Dame to peek over the convent wall. He and his fellow Irish classmates were once punished for missing school to attend Good Friday services. He kept these memories inside him and once remarked, "The Puritan has passed, but the Catholic remains."

Upon being named cardinal, he returned to his roots, where crowds filled St. Patrick Church, and he named his friend and pastor Father William O'Brien a monsignor. Each year, he came to St. Patrick Cemetery, where his chauffeur would drive him to his parents' grave and he would kneel to say a prayer. Then he would say the Memorial Day Mass. In 1921, he dedicated the chapel in the cemetery under the patronage of Saint Bridget. In 1918, the city of his birth honored him by naming Cardinal O'Connell Parkway after him, complete with a bust of the cardinal and a fountain.

Admiring the chapel at St. Patrick Cemetery, he had a larger copy built as his personal mausoleum on the grounds of St. John's Seminary in Brighton. Dying in 1944, he was buried in a one-ton bronze coffin in the chapel he had built for himself. The chapel was razed in 2011, and the remains of one of the most powerful Irish American figures was placed in a simple grave on the seminary grounds.

The Power of the Vote: John J. Donovan & Jeremiah Crowley

Politics have been part of the Irish culture since its earliest days. As early as 1833, Irishmen were involved in local and national politics. That was the year President Andrew Jackson visited Lowell, and Hugh Cummiskey was invited to be part of the delegation to meet him. The Irish Charitable Society waited for hours until the president went back to his hotel. They stayed outside, over one hundred of them, to meet the president, who shared their Irish heritage. The group made a lengthy speech extolling its devotion to American ideals of liberty. The president, on his part, spoke of his gratitude for their support and how tired he was from the day's events. But he could not leave until he shook the hand of every man. From day one, the Irish affiliated themselves with the Democratic Party. Periodic mention was made of how the growing number of Irish began influencing elections. It was obvious that old-time Yankees were unnerved. The tide was beginning to change.

Irishmen had had minor appointments in city hall for a number of years, but the highpoint was with the election of John J. Donovan. The son of Irish immigrants, Donovan and his widowed mother moved to Lowell in 1846. He started his business career in David Gove's store on Central Street. After several successful business ventures, he got into the banking field and became president of Lowell Trust Company and Washington Savings. A fervent Democrat, Donovan ran successfully for mayor and won in 1882. Obviously, his business background helped him be a competent two-term mayor. During his terms in office, bridges and schools were built, the library was made free to the public and the sewage system was improved. He remained strong in the Democratic Party and was a gifted orator.

Another of Lowell's great Irish politicians was Jeremiah Crowley. He was the son of Denis Crowley, one of Lowell's earliest Irish residents. It was Denis who carted the dead to the Catholic Burial Ground in Boston before Lowell had its own Catholic cemetery. Jeremiah was born in 1832 and educated in

the Lowell schools. He learned law under the tutelage of his cousin Timothy Crowley. He served briefly during the Civil War. Like most of his fellow Irish countrymen, he was a strong Democrat. He served repeated terms of office as an alderman, a state senator and finally mayor.

The newspapers said it was probably the largest funeral the city had seen to date (1901). The lines outside the family home on Mount Washington Street had not ceased since the news of his passing. His suffering had been long, four or five years. The cause was listed as Bright's disease. Police officers were called to help with the crowds making their way to St. Patrick Church for the funeral. The church was filled to capacity, clearly over one thousand mourners. Members of the many societies to which he belonged filled the places of honor along the main aisle. His fellow politicians, with whom he served for decades, sat in front. In the sanctuary, over twenty clergy members sat waiting for the requiem to begin. The sixty choir members prepared to chant the *De Profundis* as the casket was borne up the steps of the same church where his parents had brought him to be baptized sixty-nine years before. His nephews carried his remains up the aisle and place the flag-draped casket with a spray of flowers on the catafalque.

Following the quartet singing "Nearer My God to Thee," the remains of the Honorable Jeremiah Crowley were brought to the Catholic Burial Ground. The plot chosen was right up front near the new entrance, next to the office. The floral tributes were a sight to be seen. His fellow brothers from the AOH sent an arch of flowers over four feet high that displayed clasped hands. The police sent one about six feet high, labeled "Our Friend." When Father McHugh said the last prayer, the undertaker took the time to arrange the remaining flowers. The September sun began lowering in the sky.

Jeremiah Crowley was the ideal of the American success story. Born of immigrant parents, educated in public school, serving his country during the Civil War, passing the bar, becoming politically active and rising to the office of mayor, Crowley represented what America had to offer.

Following Donovan, there was another spell of Yankee names as Lowell's mayors. By the turn of the twentieth century, it had become like a litany of Irish saints: Downes, Maguire, Howe, Farley, Rourke, Fleming, Martin, Kennedy, Caulfield, Donoghue, Murphy and Elliott. Interspersed between these new names appeared others showing the changes taking place in Lowell. There were French Canadian and Greek names, as well. Lowell was evolving.

One name that stood out because of his close connection with the city and his Irish background was that of Paul Sheehy. A true son of the Acre and St. Patrick Parish, he was born in 1934. He attended St. Patrick

School, Keith Academy and Lowell State College and earned a law degree from Suffolk University. He served politically in the Massachusetts House of Representatives, as Lowell city manager and in several terms in the Massachusetts Senate. Beyond that, Sheehy was a founding member of the Irish Cultural Committee and traced his family history with many trips back to Ireland. He had a deep love of Irish history and culture. If there was an Irish event in the area, he was there to shake a hand and share a story.

SIX FEET UNDER: IRISH UNDERTAKERS

Undertakers were appointed by the city in the mid-nineteenth century. One undertaker was appointed specifically for the Irish community and the Catholic Burial Ground. But there was a problem. Two of the leading priests in Lowell were often at odds with each other. Father O'Brien had his man, Michael Roach, and Father McDermott had his, James Farelly. Farelly was appointed by the city, but that did not stop Roach. He kept on burying the dead, illegally. O'Brien even issued an order that he would not allow burials or sell lots to anyone dealing with Farelly in his (only Catholic) cemetery. The issue actually went to court and made quite a commotion within the community. It didn't even end with Roach's death in the midst of the proceedings. The courts ended up siding against good Father O'Brien.

If you lived in the Acre, you were most likely to use the services of O'Donnell's Funeral Home. Starting in the later half of the nineteenth century, if you were from St. Peter's, you'd go with McDonough's Funeral Home. The tradition for many families carries on to this day.

> The Lowell Sun: September 20, 1884—NEW UNDERTAKING ROOMS
> Mr. James F. O'Donnell for the past 15 years a popular conductor on the Boston and Lowell railroad, has recently opened undertaking apartments at the corner of Worthen and Market Streets. The quarters are furnished in the most elaborate style. The walls of the front store are covered in white ash cabinets containing coffins and caskets ranging in price from $10 to $150, the latter being the price for goods of the best manufacturer. Mr. Henry E.S. Kelly, a gentleman of long experience in this line is with Mr. O'Donnell and proves a most valuable auxiliary. The hearse used is one of the best made, elaborately caparisoned seen in our streets, black horses seen driving it,

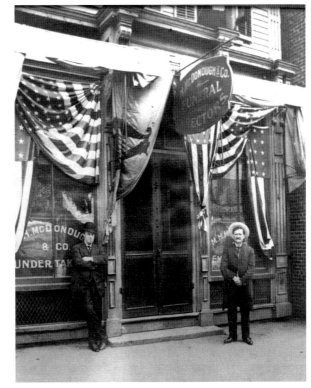

Above: O'Donnell Funeral Home advertisement, undated. *O'Donnell Funeral Home.*

Right: McDonough & Co. Undertakers, Gorham Street. *McDonough Funeral Home.*

being covered with rich black network. Funerals will be conducted in the best manner possible, and Mr. O'Donnell will spare no pains to arrange matters with the least expense possible. An electric bell connects the rooms with his residence, and Mr. O'Donnell or assistant can be called at any hour.

The tradition has carried on for four generations, and many can still recall James F. O'Donnell's grandson who carried on the business leading mourners wearing a top hat and cape. If your family is from the Acre and you're Irish, it wouldn't be a funeral without O'Donnell's.

The son of Irish immigrants, Michael McDonough apprenticed with another undertaker, James McDermott, to learn the trade. He began by making caskets. Learning quickly, he opened his own business on Gorham Street in 1906. His ad in the *Lowell Sun* ran, "Michael H. McDonough, Formerly with James McDermott, Undertaker and Embalmer, And all work connected with the business. All orders attended to at any hour of day or night. Connected by telephone. 108 Gorham Street." Mr. McDermott's ad ran directly underneath O'Donnell's. Competition was tight. McDonough's sons soon joined in the trade. A prominent member of St. Peter's Parish, he held membership in most parish and Irish organizations in the city. *Lowell and Its People* described him: "He held the respect of his large circle of friends, and was one of the men whose word was always to be relied upon." The business remains with the family to this day.

THE IRISH COP

There are myriad stereotypes that have been applied to the Irish; possibly the most popular is that of the Irish police officer. The idea that so many police officers were of Irish descent is actually based in truth. Jobs were few and far between. The position of constable was often attached with low pay and many dangers. There weren't a lot of men vying for the job.

Lowell wasn't too different. The town records of 1832 list Lowell's first Irish constable, Hugh Cummiskey. It's assumed that Cummiskey was selected to patrol the Acre section, where trouble had been brewing. There were more rows in the Acre in 1833, which possibly precipitated the addition of another Irish constable, Samuel Murray, in 1834.

Father James McDermott from St. Patrick Church had enough with the troubles going on along Lowell Street. An ardent supporter of temperance,

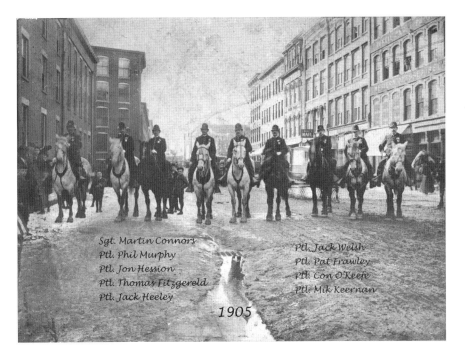

Sgt. Martin Connors
Ptl. Phil Murphy
Ptl. Jon Hession
Ptl. Thomas Fitzgereld
Ptl. Jack Heeley

Ptl. Jack Welsh
Ptl. Pat Frawley
Ptl. Con O'Keefe
Ptl. Mik Keernan

1905

St. Patrick's Day Parade, Lowell, Massachusetts, 1905. *Guy Lefebvre collection.*

he could no longer stand seeing the grog shops hidden in cellars and opening to sell liquor on the Sabbath, along with all the riffraff who accompanied the evil rum. He submitted a letter to the "City Government" in 1856, part of which said, "If boys or young men, sons of Irishmen, cannot be detected or controlled, or prevented from controlling or abusing their own countrymen, or burning and robbing their houses, by American constables or watchmen, let men of courage, of honor, men who know the vagrants be substituted." In other words, the good father was asking for an Irishman in the police force.

The city's response was predictable. A December 13, 1856 article in the *Lowell Daily Courier* retorted, "Rally, Rally, Rally…But for heaven's sake, do not appoint any more Irish police, 'who know the vagrants.' Let us 'squelch' what we have got, and put in out-and-out natives. There are plenty who dare to act in the most desperate holes in the 'Acre.'"

Alongside the iconic Irish policeman is the Irish fireman. In the same 1856 newspaper, an article appeared questioning the possibility of Captain Patrick S. Proctor being placed on the "Board of Engineers of the Fire Department." It asks, "How do the firemen relish the idea of being under Irish command?"

A quick glance at the 1921 *Lowell City Directory* lists about 200 police officers serving in the city at that time. Around 65 percent had obvious Irish surnames. For the fire department, that same directory lists about 185 men serving that year with around 53 percent having Irish surnames. Times had changed.

PLAY BALL!

Baseball is America's national pastime, or so it is said. If you want to be American, you play baseball. Every parish had a team. For many years, it was called the parochial league or the Catholic Youth Organization (CYO). There were neighborhood football and baseball teams as well, including the Acre Shamrocks, the Fighting Irish and the O'Donnell Red Wings. You didn't need to be Irish to be on these teams, but it sure helped. They played other neighborhood teams like the Polish Lions and the Belvidere Okies.

Lowell's YMCA was established in the 1890s. Father William O'Brien of St. Patrick's saw the influence that the Christian organization had drawing Catholic youth into its fold. He set about to start a similar organization called the Catholic Young Men's Lyceum (CYML). In the society's constitution of 1901, the objective was "to promote the spiritual welfare of its members, together with their social, intellectual, and physical advancements." Priests went door to door soliciting funds, and the "clubhouse" opened in 1902. It contained a basketball court, showers, a library, meeting space and space for other sporting events. Though its membership was open to any Catholic man, and other Catholic ethnic groups were well established in the city by this time, and it remained solely Irish. It was well known for its "Irish Nights" and seemed to sponsor Irish dances as well. Before "Ladies' Nights," members were reminded of the rules: maintain proper conduct when women are about, escort the lady home and "take care of her wraps and lead her to her seat."

A major event in 1898 was the visit of a group from the Gaelic Athletic Association that came to Lowell and demonstrated Irish sports such as hurling and Gaelic football. The event drew quite a crowd as they performed along Riverside Park. The forty or so players represented eleven different Irish counties, and many a Lowell citizen found a near relative in the bunch. The athletes wore green jerseys and green caps bearing the harp and shamrock. The *Lowell Sun* described it this way: "Every man was a rugged specimen

CYML (Catholic Young Men's Lyceum), 1913. *Archives of St. Patrick Parish.*

of manhood. Brawn, made in the wholesome air of Ireland, on the green hills and vales of the dear old land, was on every man of the party. Cheers went up as the champions walked onto the field. Every step was jaunty and every eye strong as an eagle's." In August 1916, the AOH sponsored a field day where two Lowell teams, the Young Irelands and the Young Shamrocks, competed in Gaelic football.

Boxing was one of the sports that was featured at the CYML. One member, Billy Lynch (aka Paddy Lynch), was the New England lightweight champion. This was the period of bare-knuckle boxing. Lowell's Irish became known quickly for their speed and agility. Paddy Sullivan, Joe Flaherty and the Gardner brothers gave boxing a civility that made backyard fighting into a gentleman's sport. At one time, the Irish had to defend themselves with their fists; now they could make a name and career of it.

"LONG LIVE OUR HEROIC HENRY"

The news arrived in Lowell shortly after he set the record. Henry F. Sullivan of Lowell became the first American to swim the English Channel in August 1923. He did it in twenty-seven hours and twenty-three minutes. When he staggered onto the shores of Calais, France, the crowds met him with cheers. Henry began his swimming career at age eleven, and by his teens, he had begun swimming from the Tyngsboro Bridge to the falls in Lowell. After completing that task several times, he swam from the falls to Lawrence, Massachusetts. He belonged to St. Patrick's CYML, to which he gave credit for his success and carried its banner with him throughout the swim.

He became a national hero, at least for a little while. He was given a check for $5,000 and the Alexander Cup, which was three feet tall and made of sterling silver. When he returned to Lowell, a grand parade and reception was given to him. It was reported that nearly the entire population of the city showed up to view the motorcade. He later toured the country as a motivational speaker.

Killpatrick's Restaurant (image from around 1917) once stood across from the old post office on Gorham Street. Mitchell Foisy is the man in white in the middle. *Courtesy of Ryan W. Owen/*Forgotten New England.

Sister Mary Flavian (Donahue) joined the Sisters of Charity in 1919 and worked at its orphanages in Massachusetts and Halifax, Nova Scotia. *Donohue family collection.*

Alumni of Notre Dame Academy, 1923. *Archives of St. Patrick Parish.*

Roger and Mary Ann (Brady) O'Connor with their children at home on Clare Street, about 1911. *O'Connor family collection.*

Part IV

KEEPING THE SPIRIT ALIVE

The first written account of a St. Patrick's Day festivity in Lowell is from 1833. Doubtlessly, the Irish celebrated their heritage before that time, but history does not record that. They were caught between two worlds. They were Irish born and bred, but they had adopted their new homeland, too. From the earliest days, they recorded their Irish legacy on their tombstones in the Catholic Burial Ground. They wept when Father Mahoney came to the Paddy Camps and spoke to them in Irish. They formed institutions that supported Irish causes and culture. They sang the songs of home and raised the green flag on the saint's day, never forgetting whence they came.

But many became naturalized citizens as soon as they were able. They joined the Democratic Party. They voted in elections. They celebrated the Fourth of July. At the same St. Patrick's Day dinners where they sang songs of home, they sang "Yankee Doodle" and toasted the president and city officials. Unlike groups that would come later in the nineteenth and twentieth centuries, those first Irish knew that they would never be able to go back to where they were born. While their feet were planted in America, their hearts longed for home.

They passed this fidelity to the Old Sod on to their children and their children's children through their churches, schools and social, charitable and religious organizations. They were a community within a wider community. Though it has been almost two hundred years since the first wave of Irish immigrants settled in Lowell, many today still refer to themselves as Irish American.

In the later half of the nineteenth century right into the twentieth, myriad groups sprang up. Each parish had its own societies to take care of its own poor and to set the young ones on the right path. There were also organizations outside the church itself that saw to it that the Irish were taking care of their own and were passing on their culture. A brief listing would include Emerald Associates; Lowell Irish Benevolent Society; Young Men's Catholic Library Association; Knights of St. Patrick; Ancient Order of Hibernians No. 1, No. 2 and No. 3; Ladies Ancient Order of Hibernians; American Society of Hibernians; St. Patrick's Temperance Society; Immaculate Conception Temperance Society; Father Mathew Total Temperance Society; Sergeant Light Guard American-Irish Historical Society; the Celtics; Irish Catholic Order of Foresters; the Emerald Club; and the Catholic Young Men's Lyceum. The list is far from complete, as organizations grew and passed away according to needs, interests and politics.

THE ANCIENT ORDER OF HIBERNIANS (AOH)

Wednesday, August 24, 1910, would be a day that the city of Lowell would long remember and not see the likes of again. It was the day of the "massive parade" for the statewide convention of the Ancient Order of Hibernians. Twenty-five thousand Hibernians converged on the city. Extra trains were coming in from every corner of the state. Every livery stable was empty, carting people hither and yon. Hotels were so overbooked that people went knocking door to door asking for a place to sleep. Humphrey O'Sullivan was the mastermind and grand marshal for the festivities, paying for much of it himself. The *Lowell Sun* and the *Lowell Courier* newspapers carried detailed information regarding every aspect of the week's itinerary. Over two hundred stores and places of business were decked out in the stars and stripes and the *Erin go Bragh* flags. The electric company actually was strung with green electric lights to the amazement of the nighttime crowds. The windows in Gilbride's store had mannequins with white dresses and green sashes with a harp posed between them. Even Little Canada, the French Canadian neighborhood, did some festooning and cheered the crowds. Mill owners were sent letters to allow employees to leave work for the day without retribution or fear of losing their job.

And the parade, oh, the parade! Ten thousand Hibernians marched the route starting around Willie Street and heading down Merrimack and

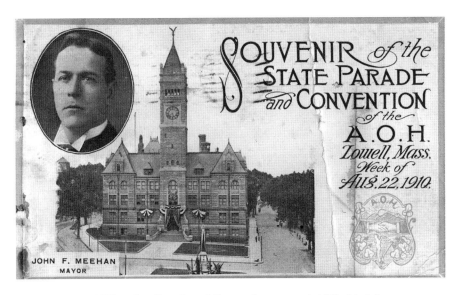

Ancient Order of Hibernians Parade and Convention postcard, 1910. *Marie Sweeney.*

Central. It took over three hours for all the marchers, bands, carriages and floats to pass by. Each division wore its distinct uniform. One wore red jackets and white gloves and carried canes. The OMI Cadets from Immaculate Conception put on a fine display of cavalry maneuvers. Mr. Mack was seen playing the Irish pipes; he was the only known player of the instrument in the area. The Wolfe Tone Guards made a fine display and should have won a ribbon, but cups and ribbons, paid for by O'Sullivan, went only to Hibernian marchers. Hackers selling postcards, along with others selling all types of souvenirs, made a great deal of business that day. The crowd, seventy-five thousand strong, surged forward as "Honey Fitz," the mayor of Boston (grandfather to John F. Kennedy), passed by Towers Corner. He serenaded them with a rendition of "Sweet Adeline."

That was the last great parade Lowell would see for many years, and within a couple decades, the St. Patrick's Day parades would cease altogether. At the time, there were several divisions of the AOH in Lowell, differentiated by parish affiliation and politics mostly. The AOH was originally formed in Ireland as a way of protecting and preserving the Catholic faith when it was being persecuted under British rule. When immigrants came to America, they saw the AOH as a way of supporting what was going on back in Ireland and as a way of doing the same here in America, where they were the minority. As more immigrants came, it became more of a social/

charitable organization. In the nineteenth century, other growing cities were forming divisions, and Lowell was among them. In Lowell in 1867, a Scottish immigrant by the name of John P. Clines, who had been an AOH member back in Scotland, proposed the idea to Daniel J. Murphy, liquor dealer and businessman, and the group was formed. The group would march in every Fourth of July or St. Patrick's Day parade, always carrying the American and Irish flags. It promoted the Catholic faith and the care of the poor and orphaned. The work is still being carried on today with a division of a men's and ladies' AOH still in Lowell.

GEORGE O'DWYER: A LIFE IN THREE BOXES

The most scholarly work done to record the story of the Irish in Lowell is Dr. Brian Mitchell's *The Paddy Camps: The Irish of Lowell, 1821–1861*. This work, printed in 1988, was the first real case study of the Irish community from its founding to its rising to the middle class. Since that time, other research has dug even deeper into those roots, giving a clearer picture of life in that period. Mitchell's work has been a catalyst to collecting and preserving the historical and cultural legacy of the early pioneers.

The great work that Mitchell and others have done really begins with Lowell's other history of the Irish, *Irish Catholic Genesis of Lowell*, written by George O'Dwyer and printed in 1920. While still in his teens, George O'Dwyer was amazing the members of the Lowell Irish Society with his knowledge of the history of Ireland and his passion for all things Irish. He was the son of immigrants and grew up in the Highland section of Lowell. He spent years poring through old newspapers at the city library. He kept hundreds of little index cards on which he would jot little stories and anecdotes that he read about. He went about the city talking to old-timers, who gave him more stories to add to his collection. These oral histories give us a look into the past that would have been lost if not for O'Dwyer, even though some of them might have been a bit apocryphal. His plan was to write the first history of the Irish in Lowell.

All of his notes and correspondences are kept in the archives at Boston College. The man's entire life is kept in three dusty boxes. O'Dwyer's story does not end happily. Perhaps his passion turned to obsession. He no longer worked full time but devoted it to getting his work published. There are letters pleading with different organizations to aid him in his cause. He used

all his financial resources to get the book in print. Four hundred copies were printed after a number of changes were made to the original text. Sullivan Bros. Printers sued O'Dwyer for nonpayment. It won and took possession of the remaining books. O'Dwyer wrote a letter stating his shock at the poor selling, even at the price of two dollars. He became dependent on his sister for food and a bed. He continued his writing, trying to get articles published, but his life spiraled downward. The man who gave so much of his life to recording the story of the Irish in Lowell and New England had a simple two-paragraph obituary, never mentioning the legacy he left to us.

THE LOWELL IRISH CULTURAL COMMITTEE

282 Suffolk Street, Lowell, Massachusetts

Lowell Irish Cultural Committee logo.
Author's collection.

When Father Richard "Doc" Conway arrived in Lowell in 1984 to take the pastorship of St. Patrick Parish, he found a church and a neighborhood broken financially and in spirit. Like his predecessors before him, he was a man of vision. He played golf with the city politicians and went jogging through the worst parts of the Acre. Soon, everyone knew Father Conway, from the men at city hall to kids on the street.

For many years, the gate leading to the church on Suffolk Street had been closed and padlocked. Father Conway opened the gate in more ways than one. He wanted the church to return to its original mission of serving the people. But he needed help.

Coming from a strong Boston Irish Catholic family, he knew the power of uniting people to get things done. He gathered a few members around him and thought of the idea of an Irish cultural committee that would bring old and new together. The festivities would take place in March around St. Patrick's Day. It took off with a bang. The church was put on the National

Register of Historic Places. A sister city relationship with Kilkenny, Ireland, was developed, and musicians, dancers and singers were brought in to perform. The highlight of each year was a Mass held during the week when the church was filled to near capacity. This was followed by a parade to city hall, where the Irish flag was raised. Such an event had not been done in decades, and since that time, it has continued.

Today, the Irish Cultural Committee still presents social, cultural and religious activities that help to preserve true Irish culture in the city. Over the last thirty years, more than three quarters of a million dollars has been raised by these volunteers to help preserve the church and to help her carry on her works of mercy. Though today's Acre has many different faces and many different names, the church remembers its past while looking toward the future.

THE IRISH-AMERICAN ARCHAEOLOGICAL PROGRAM

Beginning in 2010, Dr. Colm Donnelly of Queen's University–Belfast in Northern Ireland, in conjunction with Dr. Frank Talty and the Center for Irish Partnerships from the University of Massachusetts–Lowell, has been conducting an archaeological dig on the front lawn of St. Patrick Church. The area was chosen because of its proximity to where some of the Paddy Camps were located. Though the dig is still ongoing and not all the data has been analyzed, there have been some amazing results. Over one thousand artifacts were found in just the two pits that were dug. There were shank bones from cows, oyster shells and pig bones, all telling the researchers of the poor diet of the inhabitants. Many shards of redware pottery were found also, which point to the low economy of the area. There were clay pipes and pipe stems, which were common to the period as well. The archaeologists also found the outline of a small building, which records referred to as a "shanty," on the church grounds.

The investigation did not stop there. The team has been over twice to Crossan, County Tyrone, to excavate the Cummiskey homestead as well. This ongoing project adds more pieces to the puzzle of Lowell's Irish roots.

Archaeology dig team at St. Patrick Church, 2011. *Author's collection.*

REFLECTIONS

Generations have passed since the Paddy Camps were raised in Lowell's Acre, but what of Irish culture exists in Lowell today? Lowell is an old mill city in the heart of New England where traditions die hard. That does not mean they don't evolve. It is said a culture only dies if there is no one there to celebrate it. Surely, if Hugh Cummiskey were to rise like Lazarus, he would not recognize today's Lowell, but would he say that those Irish in Lowell today have kept the torch burning? A sampling of some who have called Lowell home and are the progeny of those who left Ireland were asked to reflect on what being Irish means to them today.

Tom Malone, Former Teacher and Administrator

Growing up in Lowell in the 1950s and 1960s, I gained pride in being Irish from my parents, Paul J. "Mike" Malone and Rita Condon Malone. But beyond the obvious symbols (e.g., wearing green, eating corned beef, shamrocks) you see with most Irish Americans around St. Patrick's Day, I did not quite understand or appreciate what my Irish ancestry meant and how it influenced my life until much later. I eventually figured out that much of my family's history was intentionally left unsaid or lost over the years, like those of many other Lowell Irish families. I also surmised the quiet melancholy that often hovered around the family was likely the result of sad family tales they preferred to forget.

Growing up in the Grove and Centraville, besides my parents and two brothers, I knew my grandparents briefly before their deaths, my parents' siblings and my mom's Hynes-connected cousins. Jeremiah Condon, my mom's brother, and my dad's sister Patricia stimulated my love of history with long conversations. My dad's sister Kay's (Sister Cecilia, a Holy Cross nun) interest and patient review of each term's schoolwork on her visits home encouraged my brother and me to achieve while we attended St. Michael School. As the first of my family to be a college graduate, I pursued a thirty-four-year career in Lowell Public Schools (principal and teacher), including teaching American history/civics while earning two more advanced degrees from UMass–Lowell. Given this background, my retirement bucket list included putting to work my education and love of history, Irish culture, historically based novels/movies and biographies and my photography hobby to undertake researching my family's story. It was not entirely clear at the time when I started this journey if my search would be fruitful.

After ten years of detective work, I am happy to say I have successfully traced my Irish roots and stories through St. Patrick Parish, the Acre and eventually to the humble town lands and beautiful countryside of Mayo, Cork and Galway Counties. I have had a great deal of pleasure and satisfaction playing history detective, connecting the missing pieces of my family puzzle and walking in my ancestors' footprints, especially in Ireland, comparing notes with my newly discovered cousins along the way and sharing what I found with my family and friends. After acquiring dual Irish and American citizenship and taking five trips to Ireland, I can say truthfully that when I am in Ireland, the faces often look vaguely familiar, and places like Blarney, County Cork, Westport and County Mayo often feel like home.

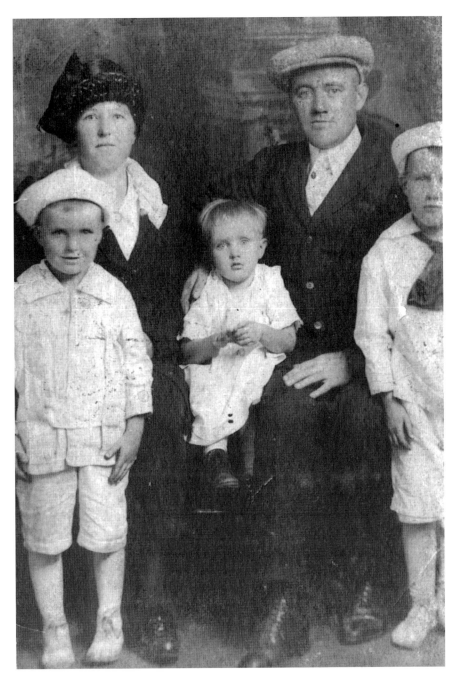

Thomas P. and Katherine Mylott Malone with three of their five children on Ludlam Street about 1919. *From left to right*: Thomas J., Patricia and Paul J. (Mike). *Thomas Malone collection.*

Rosemary Noon, Assistant Director, Lowell Plan, Inc.

My memories of growing up in a family of Irish descent are vivid. The O'Neill, Foley, Noon and Stevens families all traced their roots to Sligo, Ennis, and Inch Strand, near Dingle. In the 1980s and '90s, my parents returned to Feighroe, an area in the town of Connolly, west of Ennis in County Clare, many times, frequently spending days with relatives. My father was the most changed by the experience, and he came to embrace Irish culture seriously. For years, he took classes in speaking and reading Irish Gaelic. He proudly sang the Irish national anthem at the St. Patrick's Day Mass and at the annual flag-raisings at Lowell City Hall. When I was young, a couple Easter celebrations for me and my parents involved going to Mass at Our Lady of Good Voyage on Northern Avenue in Boston. In the small chapel built for dockworkers, I remember the stained glass was decorated with fish nets and ship models. My father would point out Séan Hughes, who always sat in the front pew. He was present at the Easter Rebellion of 1916.

John and Susan Ryan O'Neill were married at St. Peter's Church on April 12, 1899. John represented Ward 4 in the common council in 1907. His obituary mentions that he was a charter member and president of Division 8 of the Ancient Order of Hibernians and a member of Lowell Aerie, 223, FOE. *Noon family collection.*

For many families, my generation is a pivot point for understanding and appreciating a personal connection to Ireland. Some of us are three or four generations removed from those who originally came to Lowell in the 1870s and 1880s. My son, Joseph Patrick Marion, is half French Canadian. He was named after his two great-grandfathers, and he has his father's last name. However, he'll have that strong Irish middle name forever.

Paul Corcoran, Former Lowell Police Officer

As descendants of John and Mary Ellen (O'Hara) Corcoran from Skibereen, Cork, Ireland, the Corcoran family is rich with Irish pride and tradition. Since 1845, when John, Mary Ellen and sons Michael and Dennis departed Ireland at the height of the potato famine and arrived in the United States, the Corcoran family has remained true to their heritage and become "Corcoran strong." While Dennis chose to raise his family in the growing mill city of Lowell, Massachusetts, Michael headed west to raise his family and search for gold. My parents, Richard and Mae Rose Corcoran, raised their ten children in Lowell's Acre section and managed to send all ten children to St. Patrick School, ensuring their Irish Catholic beliefs and tradition. Members of my family participated for years in

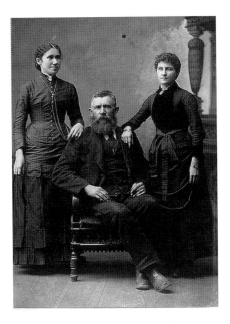

Michael Corcoran with two of his daughters. His brother Dennis settled in Lowell and brother John remained in Ireland. The three men were the sons of John and Mary Ellen Ohara Corcoran. *Corcoran family collection.*

the Irish Cultural Week shows put on by St. Patrick Parish, singing songs and performing on stage at the Lowell Memorial Auditorium.

It was in 1980, after four years of religious studies at St. John's Seminary, that my father became a permanent deacon, following in the religious footsteps of his own elder brother, Father Thomas F. Corcoran. Dad served St. Patrick Church as the Reverend Mr. Richard D. Corcoran from 1980

until his passing in 1991. My own daughters Kaitlyn and Meghan carried on the family love for Irish tradition by taking classes and becoming Irish step dancers. Both have traveled to dance competitions throughout New England, winning awards, and Meghan has competed in the World Competitions in Scotland on several occasions.

When the Boston Marathon attacks of 2013 severely wounded two of our Corcoran family members, the "Corcoran strong" motto was born. Irish traditions and beliefs are deeply rooted within the foundation of the Corcoran family. Thanks to our ancestors and these Irish traditions and beliefs, the family remains "Corcoran strong."

Garrett Sheehan, Retired Lowell Police Detective, Leading Member of the Lowell Irish Cultural Committee

My parents were both first-generation Americans of Irish descent. Their parents immigrated to America in the mid- to late 1800s. Cotter, Sullivan, Sheehan and Lynch, they came to this country with hopes and dreams for a better life. They taught their children well.

By the time I was born, only Grandpa Sheehan was alive. He had a strict rule that children "were to be seen but not heard." As a result, I do not know if he communicated with his family in Ireland. My parents did not speak very much of Ireland but mostly of growing up in their respective families. I do remember that my father had a great distaste (hatred) for the Black & Tans. He never explained why, but as I grew older, I came to understand.

My father taught his three sons to be gentlemen, both by word and action. He instilled in us a great respect for women, religion and all people we had dealings with, especially our elders. Our mother gave us our faith in God and country. Her devotion was evident in all she did. We sometimes would get upset with our mother because she spent so much time helping out the parish of St. Patrick's, in the true Irish tradition.

On St. Patrick's Day, before breakfast, my mother would burn a match and make the sign of the cross on our arms while reciting an Irish prayer. To this day, my daughter Maeghan still calls me first thing in the morning on St. Patrick's Day and asks me to recite the prayer while she performs the same rite on her children.

Ironically, having admonished my mother for giving so much time to the parish of St. Patrick's, her son has continued in her footsteps. I am very proud of my Irish heritage and have been a member of the parish Irish

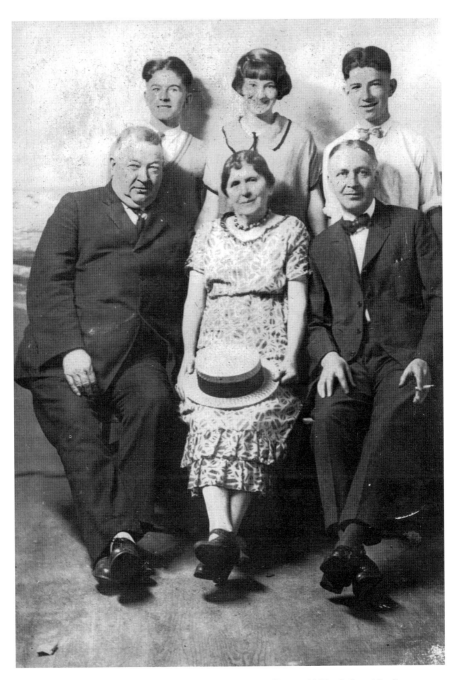

Garrett Sheehan's family at their home on West Forest Street, 1920s. *Left to right, front row:* Jack and Nora Cotter and Ed Brennan; *back row:* Ed, Agnes and Tom Cotter. Jack was a city alderman. *Sheehan family collection.*

Cultural Committee since its inception in 1984. Although we live outside the parish boundaries, our daughters chose St. Patrick Church because they felt comfortable attending Mass there. Our eldest daughter, Erin, has been an active member of the Irish Cultural Committee. We are now in the process of passing the torch to the next generation. Erin will help me with the program book next year, and eventually take over responsibility for it in the future. This desire to give back comes from both my mother's example and the teachings of the Sisters of Notre Dame at St. Patrick School. Recently, my dream came true with the complete restoration of the interior of the church.

Marie Sweeney, Former Teacher, Political Activist and Lowell Historian

From a very early time, I knew that my family roots were in Ireland. There was the music, the cultural connections, our Catholic faith, the tokens of Irish life and, of course, the stories, like the ones from our grandma Burke about her trips back to Ireland. There was just that feeling that being Irish and of the "Lowell Irish" was special and important. I was later able to make my own trips to Ireland in the early 1980s to the mid-1990s. The one that included actually visiting family took place in 1982, when Bill and I, with the boys and my parents, traveled all around Ireland in a big green VW van. We were fortunate to spend time with Michael and Nellie Deignan—he the first cousin and the "spitting image" of my grandfather Jimmy Deignan. It was emotional to say the least. We were then able to find the home—which was standing, although roofless—of Dad's maternal grandmother, Margaret McDermott Meehan. The boys, who were eleven and thirteen, had a much better sense of their heritage after the visit—meeting the relatives, hearing Papa tell stories as we drove along the roads, visiting the sacred and not so sacred sites, staying with Irish families, reading a stack of books picked up all over Ireland and even having a British army gun turned and pointed at the van after we missed a turn and came on a guard station at the border. They've retold the tale of their Ireland adventure many times to their girls. Ireland is real to them and very real to me. Years before that special trip, back in 1977, along with my sister Agnes, I answered Mayor Leo Farley's request to help with his plan to have a monument erected near city hall. It was to commemorate and remember the Irish who came to Lowell to build the canals and stayed to help build the city. As a Sacred Heart guy who knew

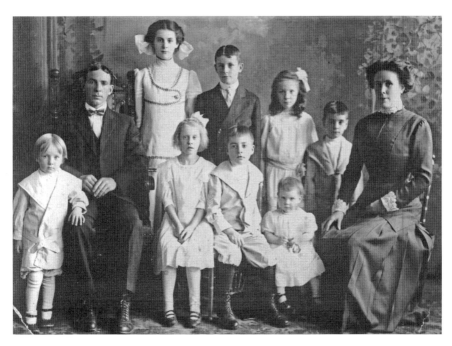

Marie Sweeney's great-grandparents Joseph Burke (at the far left) and Matilda Montgomery Burke (at the far right) with their eight children. They arrived in the United States in 1898. Joseph worked at Lowell Rendering Company. *Sweeney/Kirwin family collection.*

my dad and served on the school committee at the time with my brother, Bill, he knew that the Kirwin daughters were active politically in local historical things and seemed to get things done. I guess it was natural to seek our help, along with that of our friends Susan Callery, who worked in city hall, and Lew Karabatsos from the Lowell Museum. It was a big undertaking, but we knew people; we knew how to organize events, and we, too, wanted that Irish monument. There were certainly politics involved—getting permission to have a city site was a complicated process. There were rumblings about the Irish getting a spot; of course, as the mayor noted, the French already had a bell. And not too many years later, the Greek monument appeared on the other end of Cardinal O'Connell green space—a balance, if you will. We were very proud to be part of laying the groundwork back then for the current celebration of Irish culture and heritage in Lowell. I also see this project as laying the groundwork for all the ethnic monuments and celebratory events that have since been established, whether around city hall, in the Acre or elsewhere in the city. Each group has had a struggle to tell their story and stake a claim as part of Lowell's history and her future. I

see myself now as more a cheerleader for telling the Irish and other stories rather than as an activist. I post on Facebook and write on Dick Howe's blog to keep the events and activities on the radar screen. My four granddaughters know about their Irish heritage and are proud of it and the other ethnic heritages that are part of their mix—French Canadian, Polish, German and Scotch-Irish. The spirit and essence of my Irish heritage is in my life—it is part of my legacy.

Jack McDonough, McDonough Funeral Home

I grew up in Lowell during the 1980s and 1990s, when Lowell was as much a melting pot as anyone could have imagined. I always knew I was an Irish American but didn't really have a lot of information about that. My parents, John and Ellen (Wayne) McDonough, directed me to a history that my grandfather Joseph M. McDonough Sr. and my great-grandfather John L. McDonough had written.

Our family had come over from County Galway and County Roscommon in the 1840s/1850s. They settled in Lowell's Back Central Neighborhood, also known as the Flats, where I still live and work today. My family has operated the McDonough Funeral Home in Lowell since 1885. It is in this way that I feel connected to my ancestors the most. My brother, Joe McDonough, and I are undertakers; we are the fifth generation of our family to be undertakers. To be essentially doing what my great-great-grandfather first did over 130 years ago in virtually the same place allows me to feel a living connection with my ancestors every day.

During the holidays, my mother would always make Irish bread; hopefully, she will someday pass this tradition on to my daughters, Zoey and Morgan. When my daughters ask me what it means that they are Irish, I tell them that a long time ago, our family left Ireland, a place they loved, to find a better way of life. They did, but they never forgot about their home. I'll make sure they never forget either.

Donna Dean Reidy, Ladies' Ancient Order of Hibernians

Grandparent, parents, aunts, uncles, cousins, neighbors and friends are all part of the world you know while growing up. As a child, I was particularly aware of being Irish because my grandparents on both sides were from

Ireland. I grew up on Christian Hill near Centraville in Lowell and attended St. Michael's School with my two sisters and younger brother. We were a close-knit family who visited my maternal grandparents, Bridget and John Hartigan, every Sunday after church. My five aunts and four uncles were all musical and had great voices, so they would hold kitchen talent contests for all my cousins, awarding cash prizes of a quarter to the best singers and dancers. I know a quarter doesn't seem like much today, but it was a good amount of money back then. Everybody tried their best and were encouraged to have a new song ready or practice their step dancing for the next time.

We had great fun and a lot of laughs getting together each week listening to stories of the old days when my grandparents and parents were growing up. Of course, there were always a few scary stories that were carried over from Ireland that we wonder about today and don't know if they're true or not. Ireland was a mystical, sacred place—a beautiful country with warm friendly people—but I did hear that they have banshees flying around crying and screaming at night. Then there are those fairy trees you'd never want to sit under after hearing all the weird stories. Old Erin was intriguing but frightening at the same time, and no, we couldn't get enough stories about Ireland. Someone would always come up with a new tale to scare and delight us.

My grandparents never spoke about how difficult life was for them in Ireland. I know they had to be heartbroken leaving all they knew and loved at such an early age to start a new life in a strange country, but Ireland didn't offer a future for them. In America, they could start a business or find work to survive and support themselves, their families and even send money home to Ireland. My grandparents never spoke about any of their hardships or

Donna Reidy, Ladies' Ancient Order of Hibernians. *Reidy family collection.*

losses while trying to survive in America; it was my parents who filled us in on family history too painful for my grandparents to speak about.

As I raised my own four children, I tried to pass down some of the family history, the stories and traditions as well as special recipes for St. Patrick's Day and Christmas. The corned beef and cabbage boiled dinners, Irish bread and porter cakes full of fruit were always delicious. My family especially loved St. Patrick's Day—the Lowell parades and the light-hearted music that filled our home and lifted our spirits. As my children got older, I wanted to be more in touch with my Irish heritage and decided to join the Ladies' Ancient Order of Hibernians in Lowell. During this time, I discovered there were many early Irish immigrant unmarked graves at St. Patrick Cemetery and made a motion to adopt a cemetery project to raise funds each year to purchase and install granite cemetery markers for these departed souls. Thanks to the LAOH Inc., I have been installing new markers for fifteen years now to honor the memory of our departed Irish ancestors. My family is also involved with this special project that is near and dear to my heart, and we firmly believe that we can never do enough to thank those who came before us.

Another way of promoting Irish heritage in our home is to volunteer our time to organize Irish step dancing competitions each year, and I feel it gives us a chance to exercise a long-practiced tradition of the Irish "taking care of their own."

Victoria Denoon, Co-Director UMass–Lowell Center for Irish Partnerships

Originally I am from Holywood, County Down, Northern Ireland, but it wasn't until I moved to Lowell, Massachusetts, that I really understood what it meant to be Irish. I was fortunate to be appointed a co-director of the University of Massachusetts–Lowell's Center for Irish Partnerships, which fosters collaborations and partnerships with educational institutions in Ireland and Northern Ireland across an interdisciplinary spectrum. One of our most successful and active collaborations is with my alma mater, Queen's University–Belfast.

As part of that connection, we established the Irish-American Heritage Archaeological Program. This program involved the excavation of the lawn in front of St. Patrick Church in Lowell, the initial settlement of the Irish in Lowell commonly known as the Paddy Camps. Being involved with this

Victoria Denoon at excavation of Cummiskey homestead, Crossan, County Tyrone. *Author's collection.*

project was personally very rewarding for me. Not only did I get to work with my alma mater, but I also learned a lot about the development of the Irish community in Massachusetts and the will of people to keep the spirit of what it means to be Irish alive. That last piece is something I have become much more involved in since working on this project through my role as a director of Irish Network Boston and as president of the Queen's alumni association in New England. My interest in the history of the Irish in Lowell and the wider community and how traditions are being preserved led to Queen's University and UMass–Lowell hosting "The Irish in Massachusetts: Historical Significance, Lasting Legacy" conference in September 2014.

Coming to the great city of Lowell with its rich Irish history enabled me to find a home away from home and embrace what it means to be Irish in a place where that is welcomed and celebrated.

James Latham, Attorney, Lowell Police Department and Former Acre Resident

Growing up in the Acre in the '70s, '80s and '90s meant a great deal of pride to those in my generation. I don't remember being aware of the particulars

of what the Irish stood for other than what others would say—things like we were a "typical" Irish family, large and loud. Although not knowing the history of those ancestors who came from the old country, we understood that there was a struggle somewhere in the past. I was aware of that and was always curious about it, but when questions went unanswered about where we had been, I understood there was some pain involved. I knew Mom had become motherless before her second birthday and that her father died while she was in her early teens. All we knew is that he did his best. That is important because, being Irish in the Acre, there was always an underdog background that the Irish people shared and seemed to thrive on. Our Irish knowledge came from school and songs and, oh, that church. How many times were we told of that church that was constructed from the backbreaking work of the Irish laborers? It hasn't shrunk through the years either. It's as big and majestic as any person who has left would remember it. Our lives always revolved around St. Patrick Church. Baptisms, first communions, weddings and funerals were all witnessed by the beautiful walls and murals within that wonderful place. There is still a peace that no other place can

Latham children, 1960s. Jim and his family lived on Broadway Street for many years and were well known in the Acre. *Latham family collection.*

give that lives there. It was a meeting place where all the elders would gather after Mass and talk (mostly for too long) with one another and plan different fundraisers, whether they be bake sales or ladies' groups.

Looking back to those early years, a lot of what was common among the folks of the Acre was the closeness of families and their involvement together. Having nine kids was not all that uncommon, it seemed, and it was important to all be together often. We knew all of our friends' families, even the cousins who didn't live in the Acre. In looking back, I can see that it probably wasn't an Irish thing, but we were close with many families in the Acre. The area seemed to have a togetherness that made us tight friends, regardless of ethnicity or faith, though most were Catholic. We had friends who were Greek, French, Colombian, African American and Puerto Rican, to name a few. What did seem like an Irish thing in our family was the acceptance of each of these different people and races. Maybe it was a family thing, but I don't think my parents were any different from any other of the parents we grew up with.

As time has gone on, our family still comes to the church in the Acre for all major holidays. Although the faces inside have changed quite a bit since I was a kid, the old church still stands and gives us what we need. The old Irish traditions, such as St. Patrick's Day, might be lost in festivities instead of lessons, but those are the fun things that I remember most from St. Patrick's; singing about the unicorn and McNamara leading the band. Fun is what is remembered about all things associated with St. Patrick's, and those are the things, without getting too serious, that I would like to teach the little Lathams.

Like many Irish families, Bernard McArdle's (bottom left, seated on the floor) emigrated from Ireland to Scotland after the famine. His father then moved to Lowell, where his son Bernard owned several businesses, including the St. Charles Restaurant at the old train depot. *McArdle family collection.*

BIBLIOGRAPHY

"Annals of the Sisters of Notre Dame 1852–1958." Archives of the Sisters of Notre Dame, Ipswich, MA.

Byrne, William, and William Leahy. *History of the Catholic Church in the New England States*. Boston: Hurd & Everts Co., 1899.

Coburn, Frederick. *History of Lowell and Its People*. New York: Lewis Historical Publishing Co., 1920.

Contributions of the Old Residents Historical Association. Various volumes. Lowell, MA: Atone, Bacheller, & Livingston, n.d.

Cowley, Charles. *Illustrated History of Lowell*. Lowell, MA: Sargeant and Merrill, 1858.

CYML Bulletin. Twenty-fifth Anniversary. Lowell, MA: Mahoney Printing, 1926.

Fenwick, Benedict. "Diary and Memoranda." Archives of Archdiocese of Boston, 1825–46.

Forrant, Robert, and Christoph Strobel. *Ethnicity in Lowell*. Boston: National Park Service, 2011.

Hurd, Duane. *History of Middlesex County, Massachusetts: With Biological Sketches of Many of Its Pioneers and Prominent Men*. Philadelphia: J.W. Lewis & Co., 1890.

Kengott, George F. *The Record of a City: A Social Survey of Lowell, Massachusetts*. New York: MacMillan, 1912.

Lewis, Christine. "Fighting City." *Merrimack Valley Magazine*, November/December 2010.

Lord, Robert, John Sexton and Edward Harrington. *History of the Archdiocese of Boston in Various Stages of Its Development, 1825–1866.* Boston: Sheed & Ward, 1944.

Lowell School Committee Report, 1830.

Lynch, P.J. *Souvenir History: St. John's Hospital.* Lowell, MA, 1892.

Mitchell, Brian. *On the North Bank: A Centennial History.* Lowell, MA: Parish of St. Michael, 1984.

O'Connell, Cardinal William. *Recollection of Seventy Years.* Boston: Houghton-Mifflin, 1934.

O'Dwyer, George F. *Irish Catholic Genesis of Lowell.* Lowell, MA: Sullivan Bros., 1920.

Robinson, Harriet H. *Loom & Spindle; or, Life Among the Early Mill Girls.* New York: Crowell & Co., 1898.

Sacred Heart Review, 1892.

Sullivan, James S. *One Hundred Years of Progress: A Graphic, Historical, and Pictorial Account of the Catholic Church in New England.* Boston: Illustrated Publishing Co., 1895.

Walsh, Louis S. *Early Irish Catholic Schools of Lowell, Massachusetts, 1835–1852.* Lowell, MA: Daily News Job Print, 1901.

NEWSPAPER RESOURCES (VARIOUS ISSUES)

Lowell Daily Courier. "Another Old Citizen Gone." December 14, 1871.

Lowell Directory & Lowell City Directory.

Lowell Mercury.

Lowell Patriot.

Lowell Trumpet.

Niles Register. "In the Suburbs of Lowell." August 27, 1831.

Ohio Sentinel. "Description for Lowell Massachusetts." August 20, 1829.

Pilot.

INDEX

INDEX

W

Walsh, Bishop Louis 36, 37
Winters, Mrs. 19

X

Xaverian Bothers 71

ABOUT THE AUTHOR

Growing up on the corner of Broadway and Walker Streets gave Dave McKean a unique perspective on life. Like so many others, he grew up in the Acre, which his ancestors called home upon arrival to this country in the nineteenth century. His father regaled him with stories of Gage's Ice House, diving off the Red Bridge into the Pawtucket Canal and lighting gas lamps along Broadway Street. He loved nothing better than to listen to the old-timers, some of them still with their Irish brogues, tell of life in the mills and how they used to celebrate the saint's day. Who knew that, years later, these experiences would revisit him again when he started his teaching career?

McKean tries to give back through telling the story of those who came before us. McKean is blessed with a wonderful family: his wife and three daughters.

Visit us at
www.historypress.net
...
This title is also available as an e-book